child

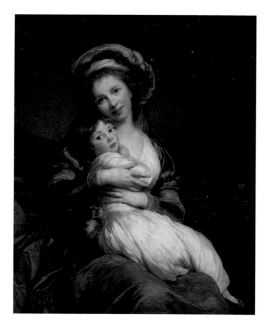

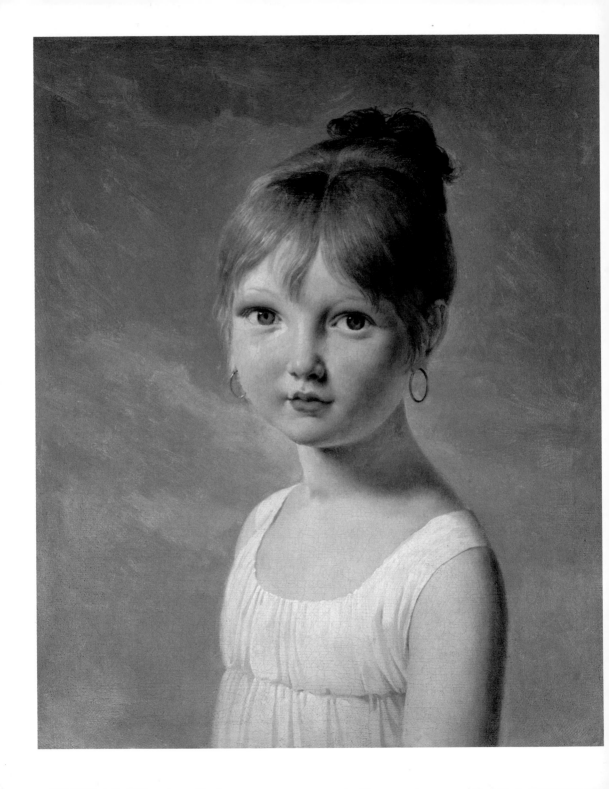

child

PORTRAITS BY
40 GREAT ARTISTS

Juliet Heslewood

FRANCES LINCOLN LIMITED
PUBLISHERS

Frances Lincoln Limited
74–77 White Lion Street
London N1 9PF
www.franceslincoln.com

Child: Portraits by 40 Great Artists
Copyright © Frances Lincoln Limited 2013
Text copyright © Juliet Heslewood 2013
Illustrations copyright © as listed on page 95

First Frances Lincoln edition 2013

A catalogue record for this book is available from the British Library.

978-0-7112-3337-9

Printed and bound in China

1 2 3 4 5 6 7 8 9

Front cover: GEORGE DUNLOP LESLIE
Alice in Wonderland c.1879

Back cover: CARL LARSSON
Brita and Me 1895

Half title page: ELISABETH VIGÉE-LEBRUN
Madame Vigée-Lebrun and Her Daughter 1786
Oil on panel,105 x 84 cm
Louvre, Paris

Title page: BARON PIERRE-NARCISSE GUERIN
The Artist's Daughter
Oil on canvas, 46 x 38 cm
Musée Calvet, Avignon

CONTENTS

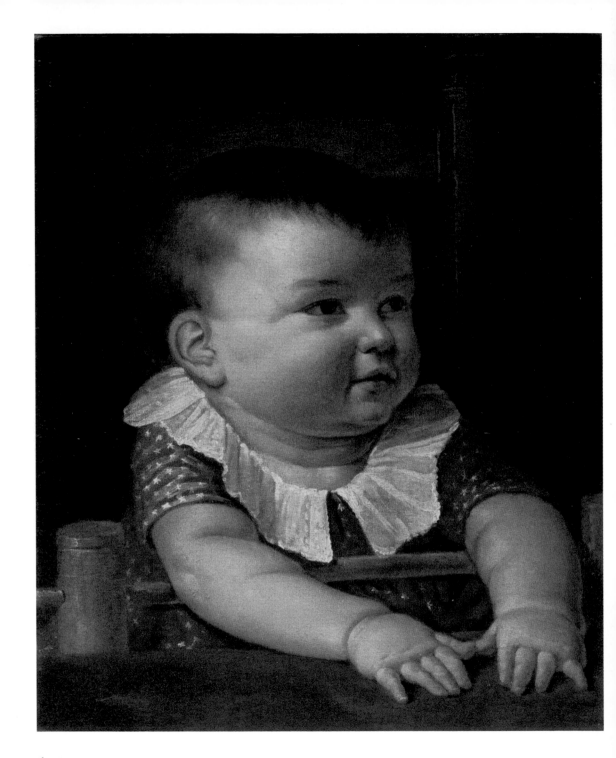

INTRODUCTION

There are said to be 'three ages of man' – childhood, adulthood and old age. The concept goes back as far as ancient times and many artists have compared these major stages in human life, adding a touch of philosophy about each. In the sixteenth century the Venetian painters Titian and Giorgione both explored the subject, proving their ability in portraying the different age groups.

A child is closer in time to its birth than an adult and, for the Romantic poets, existed in an almost sacred condition. At birth, Wordsworth explained, we arrive in the world 'trailing clouds of glory'. The more experience we have of life, the more we shed those marvellous gleams. Ageing spoils us, not because we lose our looks, but metaphysically – we are bound to become spiritually depleted the further we move away from the blessed state of being 'in utero'.

There are myriad reasons why artists have wanted to portray childhood and it is worth considering how they painted their own children. Otto Runge wanted to show children in their naturally innocent state. His motives may have been to put forward ideas for the improvement of children's social conditions. He associated children with the beauty of nature and depicted them surrounded by flowers and luxuriant plant life. 'We must all become children again to reach perfection,' he said. When he portrayed his own children, the paintings are surprisingly straight forward likenesses, lacking his usual mystic references. His nicely chubby, well-fed and contented infant son Otto Sigismund sits in a banal wooden high-chair.

Is childhood a golden age of innocence? Sweet expressions and prettiness can lend the portrait of a child the quality of uncorrupted experience. Reynolds' *Age of Innocence* shows a pert young girl sitting beneath a shady tree. She holds her hands across her chest and her bare toes peep daintily from the

PHILIPP OTTO RUNGE
Otto Sigismund, the Artist's Son 1805
Oil on canvas, 40 x 35.5 cm
Kunsthalle, Hamburg

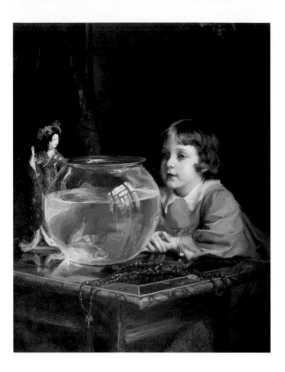

PHILIP DE LASZLO
John de Laszlo, the Artist's Fifth and Youngest Son 1918
Oil on canvas, 90.8 x 70.5 cm
Private collection

pristine folds of her white dress. Pierre-Narcisse Guerin also painted a charming young girl who is said to be his daughter (see page 2). She is seen close-up against the background of a pale, cloudy sky. She is almost smiling, calmly staring and is dressed, coiffed and jewelled like an adult. She will only need to develop breasts to leave her childhood behind and so become a perfect virgin-bride.

Children often appear busily occupied in playing their childish games. No other time exists when we can so freely do this, so the activity itself, being carefree yet brief, is at times sentimentalised. Hogarth cleverly introduced not only toys but also symbols of death and of time passing into one of his portraits of children. The Hungarian-born artist Philip de Laszlo, popular in the early 1900s in Britain as a portrait painter, frequently represented his own children at play, flattering them as much as any society sitter. Whether they blow bubbles, watch a goldfish or quietly draw a bowl of fruit, they inhabit a world of undisturbed comfort and affluence. From the nineteenth century onwards when

sea bathing became popular, artists have shown children romping about on the sands of faraway beaches, their liberty unrestricted. Such images are endlessly reproduced in contemporary greetings cards.

The child may be shown studiously attentive – drawing, painting or reading. Engaged in this way children remain still enough for the artist to capture the required likenesses. The Victorian artist George Dunlop Leslie was praised for painting 'pictures from the sunny side of domestic life'. The portrait of his wife reading to his daughter Alice captures the child's ability to imagine the world of make-believe. Her doll has been cast aside. She listens carefully, comfortable in her mother's arms.

Images of maternity go back to the earliest representations of the divine Madonna and Child. Many artists proudly painted their own families showing their wives with their children in the most generous light possible, a reflection of their personal domestic achievement. George Washington Lambert placed his wife at the centre of his carefully composed portrait group, her bare shoulders close to the flesh of his youngest, naked child. They (as

GEORGE DUNLOP LESLIE
Alice in Wonderland c.1879
Oil on canvas, 81.4 x 111.8 cm
Brighton Museum & Art Gallery,
Royal Pavilion, Brighton

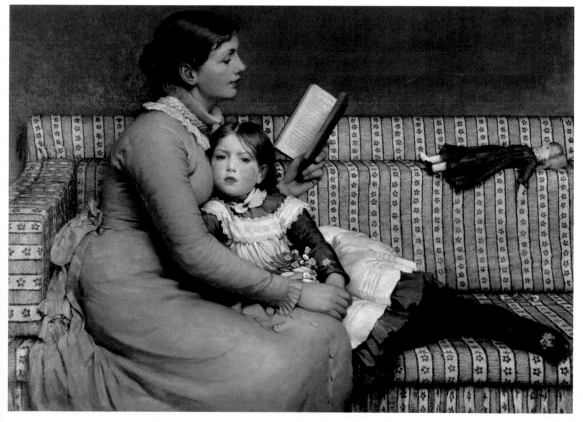

well as the horse) peer out at us from the wild landscape of Australia where they lived. In their unruffled states of dress they appear not in the outback, but as if posing in a tame garden. All is well with this family. Later, when these children had grown, Lambert made powerful portraits of each one.

In his painting entitled *Intimacy*, Eugène Carrière intended to emphasise the affection felt between close relations, especially siblings. His wife is shown mostly in shadow, her supporting hand reaching round the closely embracing sisters. The picture established his reputation as the painter of modern family life. Brothers and sisters often appear together in portrayals of childhood, whether at play or sitting less comfortably posed in formal interiors.

The self-portrait with a child is less common and often sheds light on how artists felt about their roles as parents. Elisabeth Vigée-Lebrun was used to painting members of the sophisticated French court and often portrayed herself in luxuriant contemporary dress, her feathered straw hat or silk turban hardly suited to the artist's studio. The few self-portraits with her young daughter Julie show her as demurely pretty as her child (see page 1). She wrote extensive memoirs and complained when the adult Julie disobeyed her,

GEORGE WASHINGTON LAMBERT
Portrait Group 1908
Oil on canvas, 184 x 184 cm
National Gallery of Australia, Canberra

EUGENE CARRIERE
Intimacy (or The Big Sister) 1889
Oil on canvas, 130 x 99 cm
Musée d'Orsay, Paris

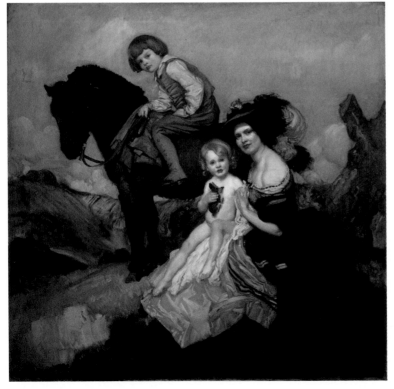

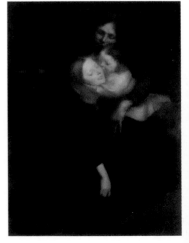

'I no longer felt the same joy in loving my daughter, although God knows how much I still cherished her in spite of all her wrongdoing. Only mothers will fully understand me . . .'

A child remains a son or daughter all through life. Not only are newborn infants represented in art, but also adolescents and adult children. Though they may no longer be innocent, maturity and experience has turned them into characterful individuals. James Durden painted a fine portrait of his son entitled *The Mountaineer*, showing him in bold profile and dressed in full climbing gear, his kit beside him at the top of the world. Presumably Durden had not scaled those heights with him, but the image says much about the character of the young man and how his father viewed him.

To be proud of a child is a parent's natural instinct. To mourn a child's loss is less easy to illustrate yet artists have taken up their pencils and paints to record ill, dying or dead children, often as mementos. Munch painted *The Sick Child* as he remembered his bedridden sister. The Scottish portrait painter Allan

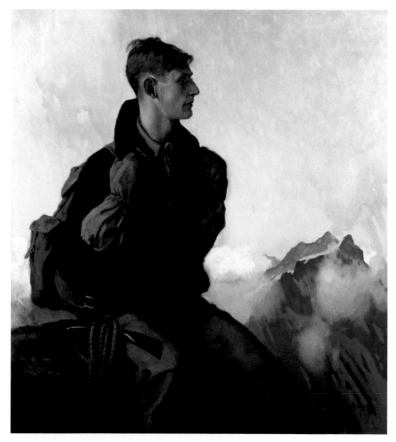

JAMES DURDEN
The Mountaineer (The Artist's Son)
Oil on canvas, 127 x 114.9 cm
Private collection

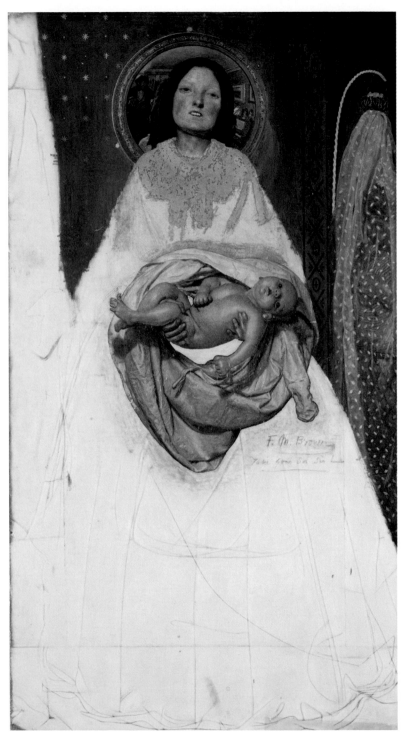

FORD MADOX BROWN
Take Your Son, Sir! 1851–92
Oil on canvas, 70.5 x 38.1 cm
Tate, London

Ramsay described how he tried to capture the appearance of his dead son and 'while thoroughly occupied thus, felt no more concern than if the subject had been an indifferent one'. Once he put down his pencil, his grief returned. William Lindsay Windus painted his pale, dead, seven-month-old child wrapped in the man's shirt, jacket and fur coat that had not been enough to warm and save him.

Children have been used to illustrate specific emotions for narrative purposes. Being near at hand, artists' own children were convenient models and appear unidentified in works, disguised in other roles. The Pre-Raphaelites often turned to their own families for the provision of suitable faces and figures in imaginary scenes. Ford Madox Brown, in his perplexing unfinished painting *Take Your Son, Sir!*, used his wife, Emma, and

their son to represent a challenging situation. Is the Madonna-like woman (her head framed by the mirror like a halo) offering the baby gladly or is the child the result of an unfortunate liaison?

Berthe Morisot, who was married to Manet's brother, was the only female member of the original Impressionist group. She submitted work to each one of their ground-breaking exhibitions except that of 1879 when she was pregnant. When she gave birth to a daughter, she wrote, 'I regret that Bibi is not a boy. In the first place because she looks like a boy; then, she would perpetuate a famous name, and mostly for the simple reason that each and every one of us men and women are in love with the male sex.' Once the baby, Julie, had grown a few years, Morisot's many paintings of her were to become some of the most enduring images of childhood belonging to the revolutionary group. Throughout her childhood, Julie was painted also by Renoir and her famous uncle. She later wrote her memoirs, *Growing Up with the Impressionists*.

Painting their own children, artists are able to offer a vision of childhood experienced from close quarters, occasionally with a hint of nostalgia, usually with devoted attention.

Juliet Heslewood

BERTHE MORISOT
Reading (La Lecture) 1888
Oil on canvas, 74.3 x 92.7 cm
Museum of Fine Arts,
St Petersburg, Florida

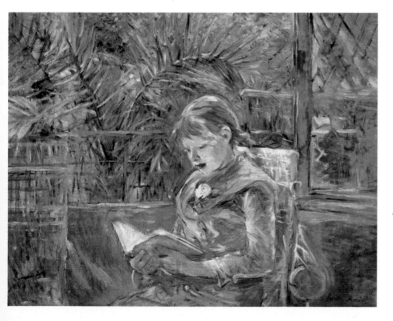

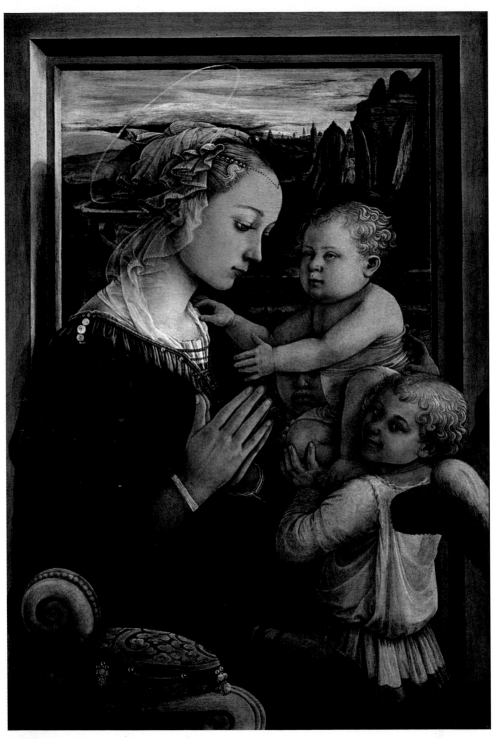

FILIPPO LIPPI (c.1406–69)

Filippino

Is the face of the young angel in the lower right side of the painting a portrait from life? Usually, where images of the Madonna include angels, saints or worshippers they gaze towards her. Here, however, is a childlike figure with an impish expression, more concerned to peer out of the picture than to pay attention to the chubby infant he precariously carries on his chest. It is suggested that this angel-child is a representation of the artist's own son. The Madonna herself is likely to be a portrait of Lippi's lover, the nun Lucrezia Buti, with whom he had an extended affair. Lippi was a monk working as an artist in Prato, near Florence, when he met Lucrezia. She had two children by him, a boy later known as Filippino, and a daughter. At the time when this panel was painted, Filippino would have been about eight years old.

In Italy during the Renaissance artists and patrons held the classical era in high regard. Florence was a commercially thriving town where accomplished painters received many commissions for work in churches as well as for private patrons. Their styles developed rapidly and Lippi's own mastery of drawing and the appealing grace of his painted work brought him significant success. Cosimo de' Medici obtained for him the decoration of the apse of Spoleto's principal church where he painted scenes from the life of the Virgin. In the main scene there is a self-portrait of the artist in monk's clothing, standing at Mary's feet. Peeping over his shoulder is another face, not unlike the mischievous angel of the earlier panel.

By this time Filippino was twelve years old. He had accompanied his father to Spoleto. It was here that Lippi died (it is said he was poisoned). Some of the last receipts for his work were signed by the young boy who then returned to Florence and became an eminent painter in his own right. Later, at Lorenzo de' Medici's request, he constructed a marble tomb for his father's body.

Madonna and Child with Two Angels c.1465
Tempera on panel, 92 x 63 cm
Uffizi, Florence

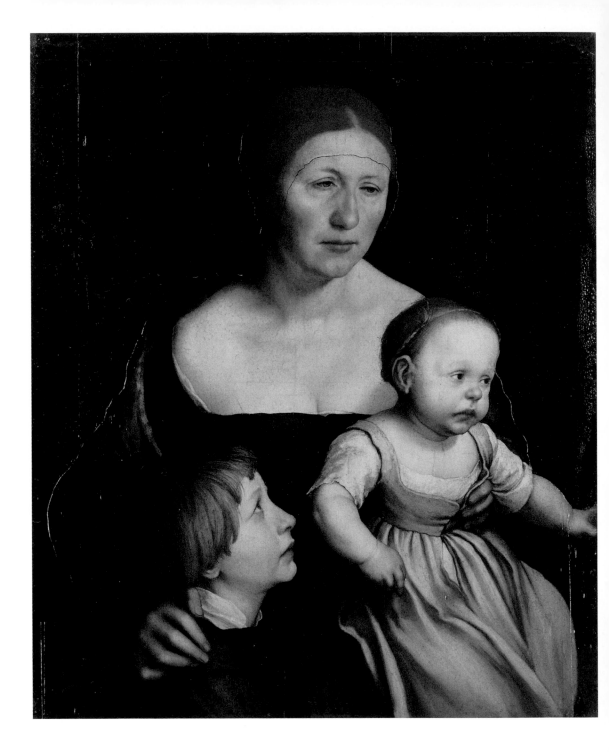

HANS HOLBEIN THE YOUNGER

(c.1497–1543)

Philipp and Katherina

On marrying Elsbeth Schmidt, in 1520, Holbein became stepfather to her son, Franz. Although only twenty-five and a little older than Holbein, Elsbeth had been married to a tanner and widowed. The young couple started their new life with good prospects since Holbein had begun a promising career as an artist, following in his father's footsteps. They lived in Basel, a flourishing town that was known especially for its printing trade. Holbein created religious scenes, stained glass and public murals but also, during this early period of the Reformation, he designed the title page of Martin Luther's Bible. In 1523 he painted his first portrait of the humanist scholar Desiderius Erasmus and was encouraged by him to seek work in England. Here he painted Sir Thomas More as well as a group portrait of More and his family.

Holbein's painting of his own growing family was done on his return to Basel where, following his success, he had bought a new house. Elsbeth is shown with the first two of her children by Holbein – six-year-old Philipp and his baby sister Katherina. The painting's remarkable realism confirms Holbein's brilliant portraiture style that was to ensure his future success. All three figures look to one side from where light illuminates their pale skin. The triangle they create was cut out and stuck on to a wooden panel that was painted dark, enhancing the attention given to their features. Each of the three faces, regardless of age, appears oddly distracted, even subdued or melancholic.

Holbein's career in England reached its height when he painted portraits of King Henry VIII and his court. Although Elsbeth had two more children, another boy and girl, her marriage to Holbein is reputed to have been unhappy. Because of his work they were often apart and in his will, though he provided well for his family, there is also mention of two infant children in England. Some years before his death, Holbein took Philipp, now a young man, to Paris to apprentice him to an eminent goldsmith in the hope that he too might have a successful career.

The Artist's Wife Elsbeth and Her Two Children 1528–9
Tempera on paper on panel, 79.4 x 64.7 cm
Kunstmuseum, Basel

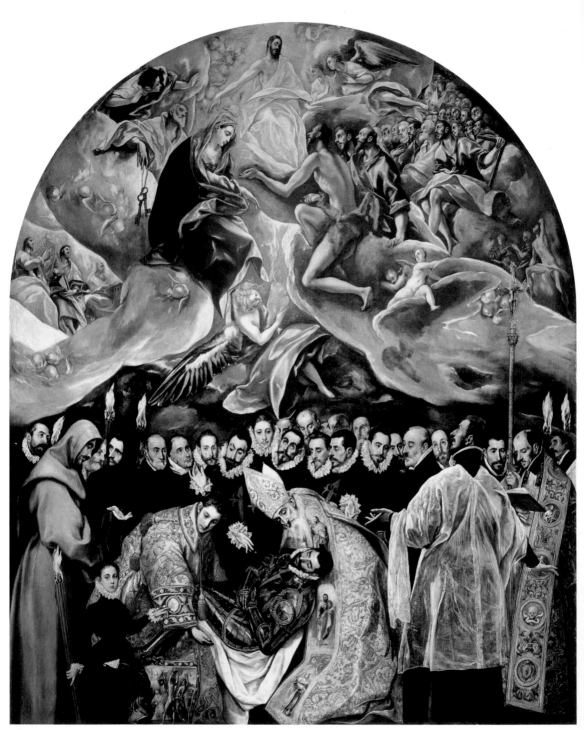

DOMENIKOS THEOTOKOPOULOS 'EL GRECO' (1541–1614)

Jorge Manuel

When the artist known as 'El Greco' (the Greek) came to Toledo, near Madrid, he was hoping to further a career that had taken him from his native Crete to Venice and Rome. Toledo was the religious centre of Spain and here he was asked to create work for several of its churches. Although familiar with the paintings of Titian and Michelangelo, he had already begun to develop an exaggerated yet unique Mannerist style.

Some years after his arrival in Toledo, his mistress gave birth to a son and though they never married, El Greco officially recognised the child as his own. When Jorge Manuel was eight years old, he appeared in one of his father's most celebrated paintings. Three hundred years earlier a pious nobleman had died, leaving money for the decoration of the church of Santo Tomé in Toledo. According to legend, Saint Stephen and Saint Augustine descended from heaven to place him in his tomb with their own hands, much to the astonishment of the local townspeople. In his large, dramatic illustration of the scene, El Greco divided the canvas between a densely populated heavenly sphere above, seen in sharply disappearing perspective, while below real personalities from Toledo stand in the middle ground watching the extraordinary scene. El Greco painted their portraits, showing them dressed in splendid contemporary costume. A single child appears in the painting, the pageboy on the left, who looks out at us, a figure entirely on his own. On his handkerchief is written El Greco's signature and the year 1578, the date not of the painting's completion, but of Jorge Manuel's birth, indicating that this is the artist's son.

Nearly twenty years later El Greco painted Jorge Manuel again, once more dressed in rich finery, the fashionable white ruff and cuffs contrasting starkly against a darker background. This time he is holding an artist's palette and brushes. He too became a painter and architect, designing several important buildings in Toledo where his father lived out his life. The portrait was admired by Picasso who made his own version of it, acknowledging El Greco's significant position in the history of Spanish art as well as his impact on more modern times.

The Burial of the Count of Orgaz 1586–8
Oil on canvas, 480 x 360 cm
Santo Tomé, Toledo

Jorge Manuel Theotokopoulos 1600–1605
Oil on canvas, 74 x 51.5 cm
Museo de Bellas Artes, Seville

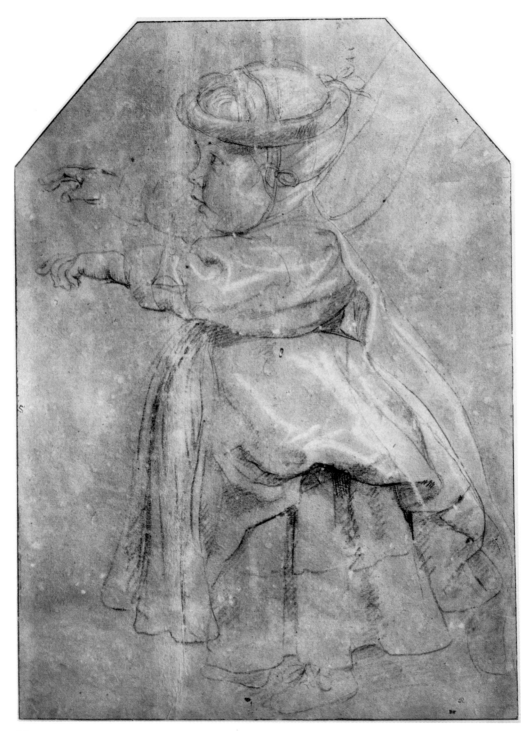

20

PETER PAUL RUBENS (1577–1640)

Isabelle Hélène

In 1635, towards the later part of his hugely successful career, Rubens bought a large estate, the Château de Steen. He planned to use it as a country retreat while still working in nearby Antwerp where he had a studio. In the same year his sixth child, Isabelle Hélène, was born to his second wife (his first wife died in 1626). At leisure in his comfortable new home, he was able to enjoy the company of his growing family.

Contrasting with the formal work he was officially commissioned to provide for the European courts, Rubens often painted his family members. He posed his younger children with their mother in scenes of warm intimacy, occasionally including himself in the portraits. The drawing of Isabelle Hélène, his infant daughter, was done when she was just a year old. The spontaneous, natural scene shows her taking some early steps. Her moving hands reach forward and she appears to have her attention fixed on something we cannot see. Pale lines at her back suggest she is being held by reins. The variety in his fine work, using several types of medium, and the detail he chose to include suggest Rubens was making a study for a larger painting. In an unfinished portrait of Isabelle's mother with her two older children, the same reaching hands can be detected in outline to the side of the picture, showing Rubens intended to include them all in one scene.

A later, finished painting shows Rubens and his wife and another child believed to be their son, Peter Paul, born two years after Isabelle. The boy is wearing the same kind of clothes that his sister wore in the study – it may even be the identical outfit, here with its colouring revealed. The tightly held band round his head is bright blue, matching fine, silky sashes across the creamy bodice and skirts. Placed together, the artist's images of his youngest children become informative records of contemporary infants' clothing.

Portrait of Isabelle Hélène
Rubens 1636
Pencil, chalk on paper,
39.5 x 28.7 cm
Louvre, Paris

Rubens, His Wife Helena
Fourment and Their Son
Peter Paul late 1630s
Oil on panel, 203.8 x 158.1 cm
Metropolitan Museum of Art,
New York

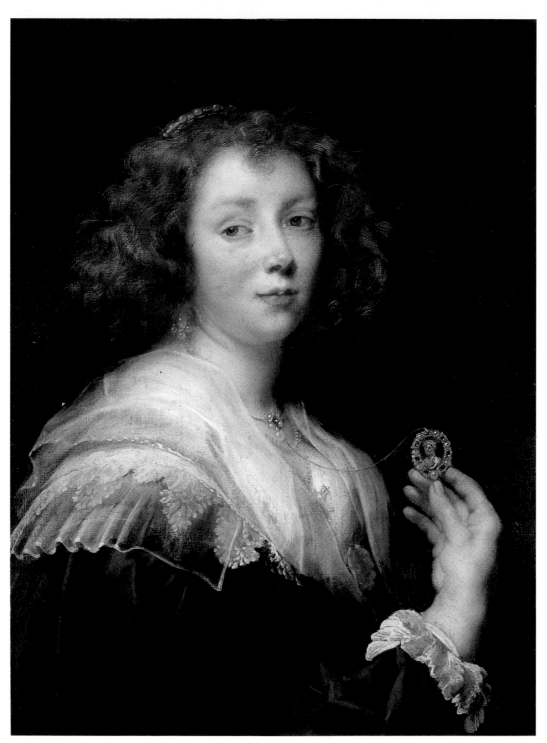

JACOB JORDAENS (1593–1678)

Elizabeth

The great Flemish masters Rubens and Van Dyck, who confirmed the artistic reputation of Antwerp, were bound to travel further afield to fulfil many commissions. Jordaens, their contemporary, who had worked as Rubens' assistant, preferred to stay in their home town. On marrying his former teacher's daughter, he completed his own marriage portrait, just as Rubens had done. Jordaens also painted an image of himself, his wife and their daughter, Elizabeth, when the child was about four years old. The little girl is seen holding a piece of fruit in one hand and a basket of flowers in the other – a means of naturally introducing symbolic content into the portrait.

Elizabeth, being unmarried, stayed at home to look after her father after her mother died. She appears in several of his paintings as a young adult – her full figure and cheerful expressions are well placed in convivial genre scenes. In one portrait of the attractive, smiling girl, she wears a characterful straw hat attached to which is a branch of honeysuckle and the feather of an ostrich – symbols of love and truth. An earlier, more formal portrait is subdued in colouring and invites interpretation of its symbolism. Elizabeth holds up the golden pendant she wears on a chain round her neck. Meticulously painted, it includes an antique bust surrounded by pearls and diamonds, and leads us to question who the head represents. Other pearls appear on a second and third necklace as well as on her earring and headband. Why does Elizabeth wear black, the colour of mourning? Pearls may represent purity, love or truth. What did Jordaens mean by these references?

In Antwerp the official religion practised was Catholicism. Jordaens converted to the Protestant faith later in his life and was fined for some of his writings that were considered heretical. He died of a plague-like illness known as 'the Antwerp disease' on the day that Elizabeth also died of it. They were placed beneath the same tombstone where her mother had been buried, in a small Protestant cemetery north of the Belgian border.

Portrait of a Young Lady 1637
Oil on canvas, 74.5 x 55.5 cm
Akademie der Bildenden Künste,
Vienna

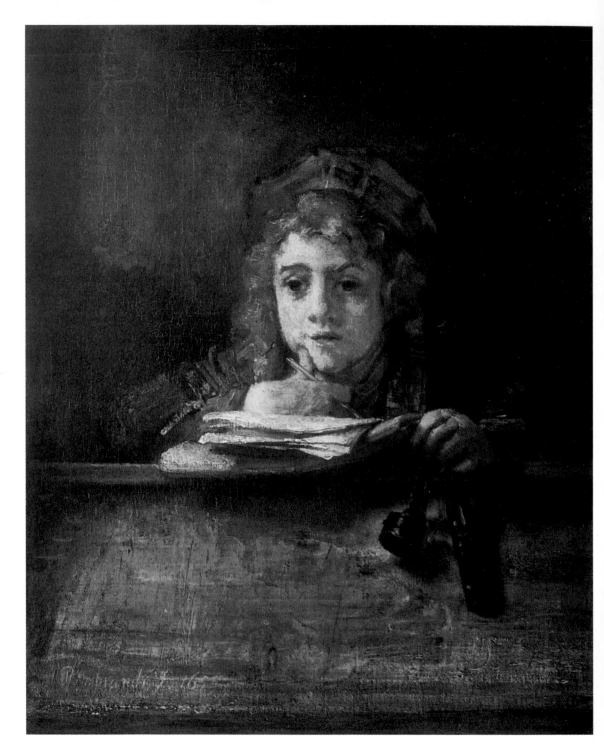

24

REMBRANDT VAN RIJN (1606–69)

Titus

The boy at his desk appears to be deep in thought, momentarily distracted from his work, concentrating. Rembrandt's son Titus, to whom he taught painting and drawing, was the only child from his marriage to survive. His later role was not as a protégé but, faced with Rembrandt's humiliating financial responsibilities, as a businessman and dealer. His father became his employee.

In this portrait of fourteen-year-old Titus, he is illuminated from a single source forming a central, triangular area of light in a darkened interior. The desk on which he leans takes up a third of the picture and is painted in a sweep of varied, rough strokes. His face, hair, clothing and papers are all highlighted by thick additions of colour worked upon lower layers of paint. The subdued chiaroscuro of the image and its highly textured surface are similar to the many self-portraits Rembrandt made throughout his life.

Titus was only nine months old when his mother died and he was later cared for by two women who came into Rembrandt's household initially as servants. At the time of this painting, in order to gain some financial security, Rembrandt transferred ownership of his house to Titus but required him to make a will returning the estate back to him in case he died. It is thought that the moment depicted in the portrait represents this transaction, although the unpolished desk and the pen and ink-case held by Titus do not indicate a formal setting. When household furnishings were being sold, Titus bought with his own money an ebony framed mirror that Rembrandt may have used when painting himself. Sadly, it broke into pieces during the removal.

Rembrandt painted other portraits of Titus – one as a monk, one showing him reading a book and one as a finely dressed young man wearing a gold chain round his neck. Titus married but his daughter, Titia, was born after his untimely death. At her baptism, Rembrandt acted as her godfather.

Portrait of Titus 1655
Oil on canvas, 77 x 63 cm
Museum Boijmans van
Beuningen, Rotterdam

Figure of Lydia Dwight 1674
Salt-glazed and hand-modelled stoneware, 25.5 x 20.5 x 11 cm
Victoria & Albert Museum, London

JOHN DWIGHT (c.1635–1703)

Lydia

Lydia Dwight was only six years old when she died. Infant mortality was common in the seventeenth century, but Lydia's family must have grieved deeply at the young girl's death, deciding to create a memorial to her. Though an early experiment in the use of stoneware and ceramics, the private purpose of the figure meant it was not intended for any kind of public exposure. Together with other pieces, it was kept as a family heirloom for nearly two hundred years.

The lovely half-length figure probably shows a likeness of Lydia's face. It was carved not long after she died and shows her small body carefully dressed, her head resting on a pillow. Her eyes are closed and her mouth almost smiles in the stillness of death. The intricate handling of details such as the lace framing her face and the bunch of flowers she clasps to her breast show to what extent the potter's craft could be compared to the art of sculpture.

Lydia's father, John Dwight, experimented with the properties of clay and mineral materials in the production of stoneware which had previously been known only in Germany. In 1671 he obtained a patent for his research and claimed to have 'discovered the mistery of transparent earthenware comonly knowne by the name of porcelaine'. His pieces later became as highly regarded as those from abroad and he set up a factory in Fulham where, for years afterwards, fine pottery continued to be made. Though he probably used modellers from other countries (who have never been identified), Dwight's experimental work and its success contributed to the foundation of the pottery industry in England.

Another image of Lydia was made at the Fulham pottery, probably at the same time as the recumbent figure. This also is pure white – a fitting colour for mourning a child – and shows her standing, with flowers and a skull at her feet. She wears only her shroud, but she is moving, one step foward, as if resurrected from the dead.

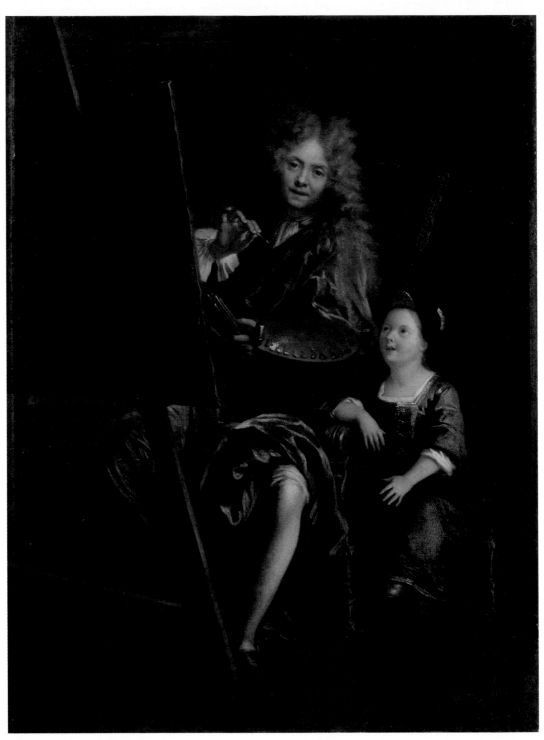

ANTOINE COYPEL (1661–1722)

Charles-Antoine

Painting in seventeenth-century France, during the period known as Baroque, was essentially dramatic. When it came to portraiture, sitters were often shown in striking poses, strongly lit and with a formality that hardly imitated real life. Throughout European courts, royalty was portrayed as refined, elegant and distinguished.

The Coypel family had long associations with painting at the French court. As a young man Antoine Coypel spent four years in Rome with his father, a director of the French Academy there, learning from him and from Italian art. He then began a career that was to become even more successful than his father's.

When commissioned to paint the panel of a cupboard door, Coypel portrayed himself with his four-year-old son Charles-Antoine. The artist is shown working in his studio but dressed in the fine clothing of a courtier. Daintily he lifts his brush as if it were a teacup. His palette is hardly worked, but neatly laid out with colours from dark to light. Next to him is his child sitting sedately, cross-legged, staring up to admire the fine painting. It was once thought to be a portrait of father and daughter, the boy's dress and posture being so feminine. Both figures are strongly lit from the side while the rest of the empty studio lies in relative darkness.

When Charles-Antoine grew up it is hardly surprising that he too became a painter. Had he spent years watching his father at work, as the double portrait suggests? He certainly followed his father's formal style becoming Chief Painter to the Duke of Orleans, and was allowed to live at the Louvre Palace. He also became Director of the Royal Academy and Chief Painter to the King when his father died. Charles-Antoine enjoyed the theatre and wrote several plays. As well as painting eminent members of the court he made portraits of actors, including the great dramatist, Molière. Having walked in his father's footsteps, as his father before him had done, the family tradition continued to be favoured in an increasingly grand and self-conscious society.

Self-portrait with His Son Charles-Antoine 1698
Oil on canvas, 59 x 42 cm
Musée des beaux-arts et d'archéologie, Besançon

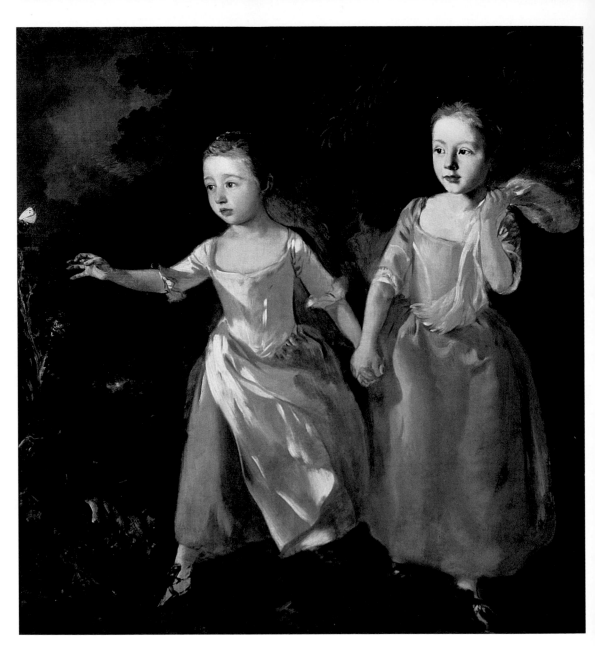

The Painter's Daughters Chasing a Butterfly c.1759
Oil on canvas, 113.5 x 105 cm
National Gallery, London

THOMAS GAINSBOROUGH (1727–88)

Mary and Margaret

When Gainsborough painted this early picture of his daughters, the family had not yet moved to fashionable Bath where he hoped to advance his career in portraiture. He had been painting formal, conventional compositions but was now moving towards a looser handling of paint that later brought him greater success with his portraits of British nobility. The painting of his daughters was a personal choice, not commissioned or for sale. In it he could practice this lighter technique that he eventually achieved with rapidity, using extremely long brushes and giving the works an 'unfinished' appearance.

The girls, Mary and Margaret, would have been familiar with the Suffolk countryside near their home, but here they inhabit a stage-set woodland. It is almost night and a storm approaches. Their fine, silver and gold dresses are hardly suited to the roughness of a rural location, nor their daintily ribboned shoes to the muddy ground. Unconcerned, their attention is fixed upon an elusive butterfly. The light, too harsh for the setting sun, strongly illuminates their faces, which reveal their simple delight in spontaneous play.

The unlikely scene was probably set up by Gainsborough, who is known to have worked late into the night in his studio, using candlelight rather than the natural light of day. Though immediately appealing, the painting's juxtaposition of dark elements with light reflects its deeper message. The younger child eagerly reaches out to the butterfly. Her hand is tightly held by her sister whose more refined, older features look on with a hint of concern. The butterfly will vanish and the moment will fade, just as the time of their childhood and innocence will inevitably pass.

Mary was not two years older than Margaret and their lives ran closely together. They went to the same school in London and Gainsborough, hoping they, too, might become artists, encouraged them to draw and paint. Though he loved music, he was concerned when Mary married one of his friends, a celebrated oboeist. This marriage failed, enabling the two sisters to live together again.

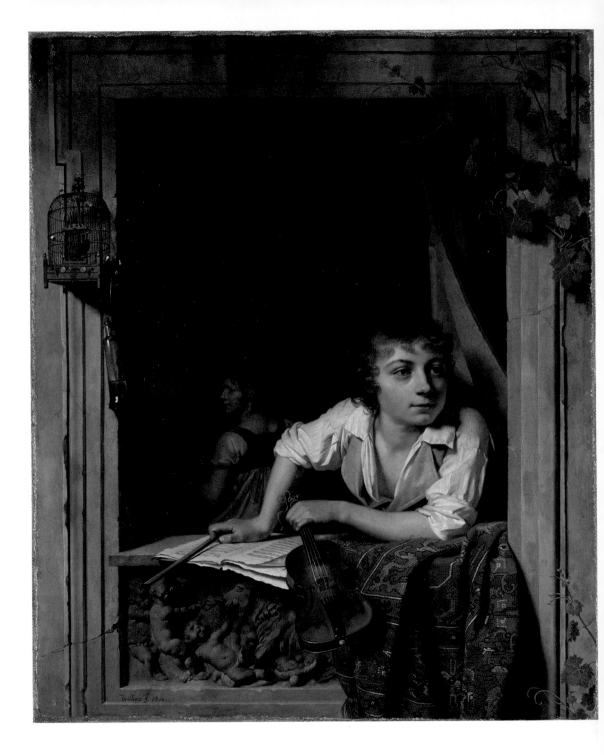

MARTIN DROLLING (1752–1817)

Michel-Martin and Louise-Adéone

With this portrait of his children (his son in the foreground and his daughter in the background), Martin Drolling referred to a type of picture known as *vanitas*, popular in the Netherlands in the seventeenth century. The still-life was created using objects that held symbolic meaning and usually pointed to the transience and fragility of human life. Drolling had trained in Paris and supplemented his learning through studying Flemish and Dutch old masters in the Luxembourg Palace. His own style developed with this knowledge in mind and his subjects ranged from historical or religious to genre scenes. The meticulous, highly finished detail of his brushwork was particularly suited to rich interiors and portaiture.

His son, Michel-Martin, has paused while playing his violin and leans from a window, his attention drawn to something outside. Light falls to illuminate the varied textures of his hair and clothes, a sumptuous carpet, vine leaves and the ageing condition of the finely carved stone framework. Behind him his sister, who is painting, also pauses and looks round. Although the objects appear naturally placed, the whole scene is composed within an imaginary window. The Dutch painter Gerard Dou had frequently used this kind of device which Drolling successfully borrowed. The window's sculpted baby-like putti appear to be in a struggle quite unlike the calm, occupied older children. The bird in its cage suggests the music of the title and the hanging palette and bottle of oil are artist's materials. The growing vine contrasts well with the cold stone.

Drolling had earlier painted the younger Michel-Martin dressed charmingly as a drummer boy suggesting once again the importance of music for this particular child. Yet Michel-Martin followed in his father's footsteps and became a talented painter of historical and mythological scenes, winning the prestigious Prix de Rome when he was twenty-four. This allowed him to study art in the great Italian capital. Louise-Adéone continued to paint and, like her father, gained much success with scenes of middle-class, domestic interiors and portraiture.

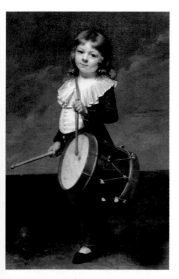

Painting and Music (Portrait of the Artist's Son) 1800
Oil on canvas, 45.7 x 37.4 cm
LA County Museum of Art,
Los Angeles

Portrait of the Artist's Son as a Drummer late 18th century
Oil on canvas, 120 x 76 cm
Private Collection

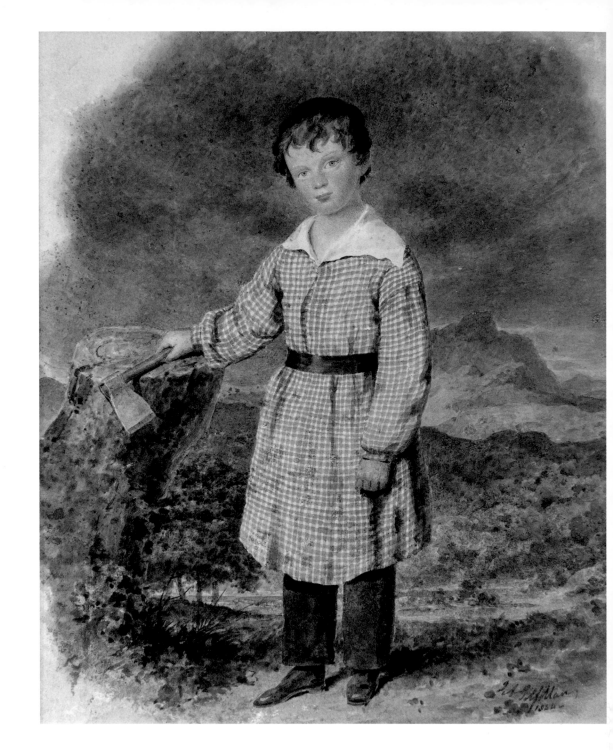

JOHN ALEXANDER GILFILLAN
(1793–1863)

John Gordon

The pioneering spirit of the mid-nineteenth century encouraged many British people to seek new lives in unknown territories on the other side of the world. John Alexander Gilfillan is said to have once run away to sea and served in the Royal Navy. Later he spent years teaching drawing and painting in Glasgow before setting off with his family for New Zealand in 1841. On arrival in the beautiful, fertile area of Wanganui, he took up carpentry and engineering with a view to farming. As an artist, he was interested in the local Maori communities and made several drawings of them, recording the changed lifestyle that the integration of foreign settlers had created in their rich, sacred land.

The watercolour painting of his son, John Gordon, here aged about six, shows the child posing against a rugged, mountainous landscape. Wearing an immaculate, belted smock and shiny leather shoes, he is hardly dressed for tree-felling; nor would a child of his age have anything to do with such dangerous labour. The image suggests the ideals of colonisation and in choosing to show such a young protagonist, Gilfillan made reference to the settlers' hopes for the future.

Three years after the painting was made, a group of Maori attacked the Gilfillan family. Resentment towards the 'pakeha' (someone not of Maori origins and in particular of white colouring) had been increasing. Gilfillan's wife and three of his children were killed. He and his elder daughter were wounded and their farmhouse destroyed. John Gordon and his younger sister were apparently found wandering in the bush before their rescue by a search party. The survivors moved to Australia, firstly to Sydney where Gilfillan painted a peaceful village scene based on some of his earlier work. This was taken to England and both Prince Albert and the Duke of Wellington admired it. It was included in the New Zealand Court of the Great Exhibition in 1851. John Gordon later returned to New Zealand where, in 1875, he died in a canoeing accident on Lake Rotorua.

Portrait of the Artist's Son, John Gordon Gilfillan 1844
Watercolour on paper, 24 x 20 cm
Fletcher Trust Collection, Auckland

JOHN EVERETT MILLAIS (1829–96)

Effie

The rebellious young artists who called themselves the Pre-Raphaelite Brotherhood (because they admired aspects of art from before the time of Raphael) preferred using their own friends and families as models in order to obtain life-like appearances in their work. As their individual careers developed, Millais became a highly successful exhibitor at the Royal Academy and a brilliant portrait painter.

Effie, who was born in 1858 and named after her mother, was his third child out of eight. Millais did not hesitate to use each one of them in his work. These paintings were often more than simple portraits and represented certain ideas. Since children were their main subjects, they tended to become rather sentimental to suit the taste of the Victorian public.

Five-year-old Effie is the good little girl seated in her Sunday best listening to a sermon. The church, with its old box-pews, was in Kingston-on-Thames where Millais' parents lived. Beside the girl are the clothes of her mother, though she is not shown. The implication is that the attentive, obedient child ought to learn from what she hears without distraction. The painting's immediate popularity was probably due to his treatment of his model, the engaging Effie. Two days after it was exhibited Millais made a second version which was sold immediately. 'I never did anything in my life so well or so quickly,' he later declared.

Millais knew much about children. Often he found it difficult to manage those who sat for him and tempted them with treats to do as they were told. Aware of the success of *My First Sermon*, he followed it up with a pendant. In *My Second Sermon* Effie is seen in that same pew, her hat discarded, her face now deep in sleep. The Archbishop of Canterbury at the time claimed this painting was a warning against 'the evil of lengthy sermons and drowsy discourses'. Millais was surely illustrating a child's natural resistance to enduring the formal situation. Effie was later to model for her father's painting of *Little Red Riding Hood*.

My First Sermon 1863
Oil on canvas, 92 x 76.8 cm
Guildhall Art Gallery, London

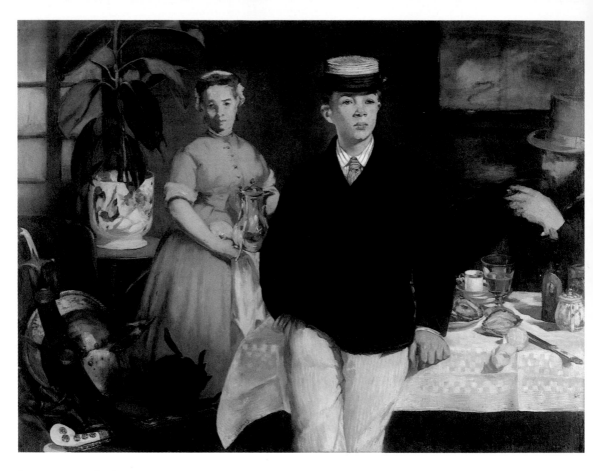

Luncheon in the Studio 1868
Oil on canvas, 118 x 154 cm
Neue Pinakothek, Munich

EDOUARD MANET (1832–83)

Léon Leenhoff

Who was Léon Leenhoff's father? He was born into the Manet household where his Dutch mother, Suzanne, was employed to give piano lessons to the family. To please this socially conscious circle, Léon was passed off as her younger brother. Manet used the young Léon as a model in several of his early works as he was near at hand. Later, once his own father had died, Manet officially married Suzanne having lived with her and Léon for some years. Whether he was related to the boy by blood or not is unknown, but he assumed the role of his father.

By the time of this painting, Léon was sixteen years old. He stands a little off-centre, but well in the foreground of what becomes, the more it is considered, a perplexing scene. It is lunchtime – or is lunch over? Opened oysters and a half-peeled lemon remain uneaten although coffee is being served. Has Léon turned round from where he was sitting, about to move in the direction of his gaze? He is accompanied by a servant

and a friend of Manet's, the artist Auguste Rousselin. Yet none of the three people in the painting seem to communicate with each other. They remain detached and still while an unnatural atmosphere prevails.

The painting brings together several areas of still-life. To the left, almost in shadow, is a collection of arms carefully arranged on a chair where an almost invisible small black cat washes itself. In the background stands a healthy looking plant in a patterned pot. To the right, the table is set with objects of different textures – a protruding knife, crystal glass, ceramics, food – reminiscent of other still-lifes painted by Manet.

Light and dark play across the painting in strong contrasts between white and black with Léon's dark jacket like a flat void in the centre. The yellow in his jaunty hat, striped tie and trousers is repeated in the lemon peel and sword handles. Everything – and everyone – exists in a scene that depicts not a real social occasion, but specific elements arranged within the artist's studio.

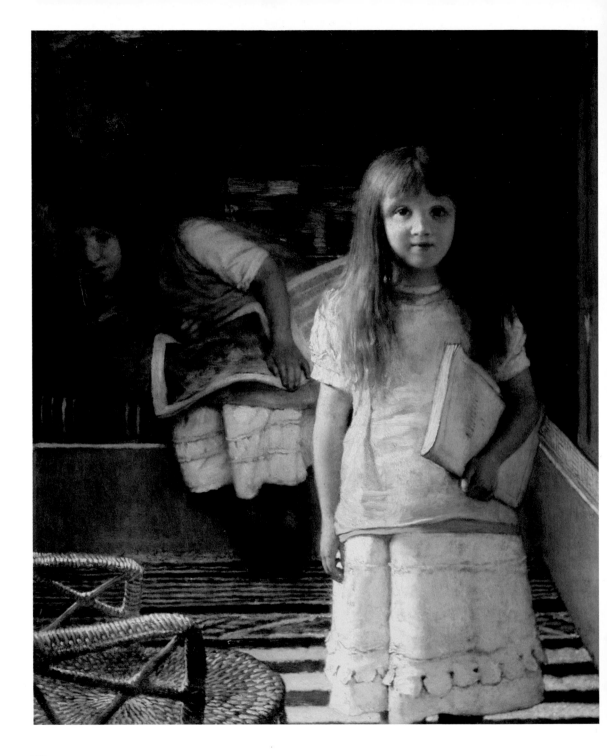

LAWRENCE ALMA-TADEMA
(1836–1912)

Laurense and Anna

Scenes of the classical world and the decadence of ancient Rome brought the Dutch-born artist Alma-Tadema his greatest success. He first achieved recognition, however, with a painting entitled *The Education of the Children of Clovis* which showed an imaginary view inside the court of the early French King. The Royal Princes are seen in a stately, marble-lined yard where their mother, the Queen, supervises their rigourous training in axe-throwing.

Twelve years later, Alma-Tadema painted his own children in the relaxed environment of their luxurious home, Townshend House near Regent's Park in London. The mother of the two girls had died while they were very young and the painting was given to their stepmother, Alma-Tadema's second wife, who herself had no children.

As the title suggests, Laurense and Anna occupy one corner of what appears to be an exotically furnished room. A striking black and white carpet lies across the floor in the foreground. Eight-year-old Laurense stands in a pale dress and is lit from an unseen source to her right. Behind her, in shadow, Anna lies against a huge cushion that probably matches the one bearing an oriental design against the far wall. This corner must have been an inviting place to play, though the girls are seen with large books, implying they read quietly here. A wicker chair in the foreground marks the edge of the space. Has Laurense been sitting here? Has she stood up to greet somebody? Both girls stare out at us as if they have just been approached, even disturbed. Laurense waits to speak whereas Anna appears shy, reluctant to leave the comfortable furnishing of their sanctuary. Alma-Tadema may have wanted to emphasise their containment within this enclosed, private space as a reference to the brevity of childhood and innocence.

Once grown up, Laurense became a writer and Anna an artist. Anna painted several views of the fabulously decorated interiors of their house before the family moved away.

This is Our Corner 1873
Oil on panel, 56.5 x 47 cm
Van Gogh Museum, Amsterdam

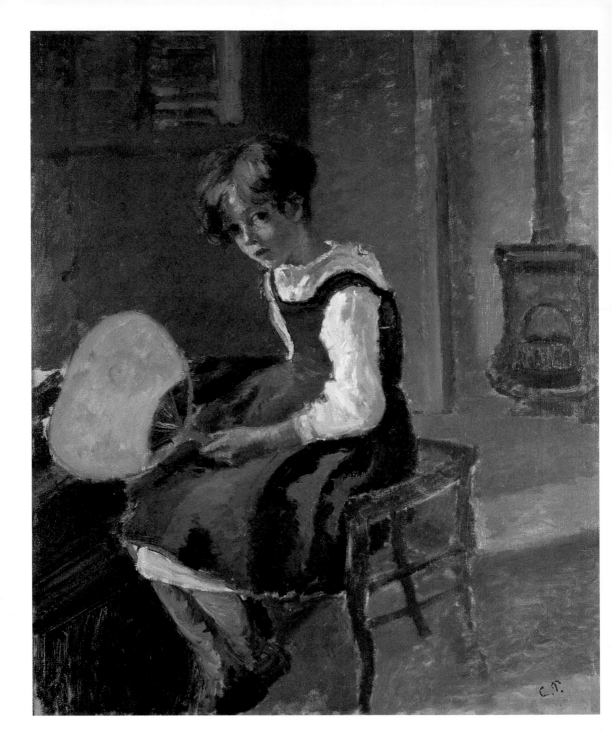

CAMILLE PISSARRO (1830–1903)

Jeanne-Rachel (Minette)

Pissarro was considered by the Impressionists to be the 'father' of their group. Having revolutionised traditional aspects of painting, they risked the disapproval of their contemporaries, but persevered in their ideals. Pissarro exhibited in all of their controversial exhibitions, beginning in 1874 and continuing for the next twelve years. Primarily a painter of landscape, Pissarro worked in several villages on the outskirts of Paris as well as in studios in the city where he could meet his fellow artists. He used the people near to him, especially his family, in representations of their own lives – part of the contemporary world that the Impressionists claimed as their subject matter. Most of the paintings of his children are not dated, suggesting they were not considered for exhibition or sale, but to keep for himself. Jeanne-Rachel, named after her two grandmothers, was Pissarro's second child out of eight born to the family. From infancy she was known as 'Minette' and her father often painted her in single portraits, sometimes in

brisk watercolour. Here the tone is subdued, mostly of browns, and her blue dress introduces a patch of colour to the composition. White appears beneath her pinafore and in the Japanese fan she holds. The fan is a reference to the interest the Impressionists took in the art of Japan, which offered them new ways of representing the world.

Minette sits in a bare room, probably her bedroom if the item of furniture behind the fan is a bed. The vertical lines of a window's framework, a door and a stove relieve the emptiness of the background space. She leans forward, looking up, her back slighty hunched. Her cheeks are flushed, their red colour repeated in the brushstrokes of the wall behind her head.

In October 1873 Pissarro wrote to the doctor explaining that he and his family were 'half dead with worry and concern' because Minette was suffering from tuberculosis. She died the following year. In 1881 another girl was born, also called Jeanne, and later nicknamed 'Cocotte'.

Jeanne Holding a Fan 1873
Oil on canvas, 56 x 46.5 cm
Ashmolean Museum,
University of Oxford

A Corner of the Apartment 1875
Oil on canvas, 81.5 x 60.5 cm
Musée d'Orsay, Paris

CLAUDE MONET (1840–1926)

Jean

In the mid-1870s several Parisian-based artists moved out of the city to paint scenes on the Seine, a short train journey from St Lazare station. They could easily return to the city to keep in touch as they strived to alter the contemporary art scene. Out in the country these painters, who were branded as mere Impressionists, were able to study the real world in which they lived, working *en plein air*, that is, outside, not in the studio. Monet moved to Argenteuil in 1871 and it is here that he had a studio-boat made. From it he painted not only the river's changeable surface, but also, from a strategic position, the riverbanks, their reflections and the distant reaches of his new environment.

Over the following years, he frequently painted his wife, Camille, and his young son, Jean. They appear in different places and in all seasons, at home or by the river. Walking through poppy fields, sitting in the shade, watching, playing – Monet documented their out-of-doors life in paint. His love of flowers and his interest in the creation of gardens is evident in many sun-filled scenes that culminated decades later with his extraordinary achievements at Giverny, some fifty miles downstream.

The painting of Jean and, almost imperceptibly, Camille, in a darkened interior, seems atypical of early Impressionist work. The scene is carefully composed in a symmetrical design with the silhouetted lamp and the 'v' shape of the parquet floor dividing the picture into two halves. On either side, framing the interior, are bright orange, patterned curtains that could be taken for flowers on the stalks of the potted plants. Standing off-centre, his hands in his pockets and his head quizically leaning to one side, Jean looks out through the open space. Monet's own title for the painting, when he sold it the following year, was simply as an interior, his 'blue painting'. The deep blue central area is strengthened by the foreground orange, repeated in the hanging candelabra and flecks of paint on the floor. This is not a narrative scene of life in his Argenteuil home, but a bold exercise in contrasting forms and colouring.

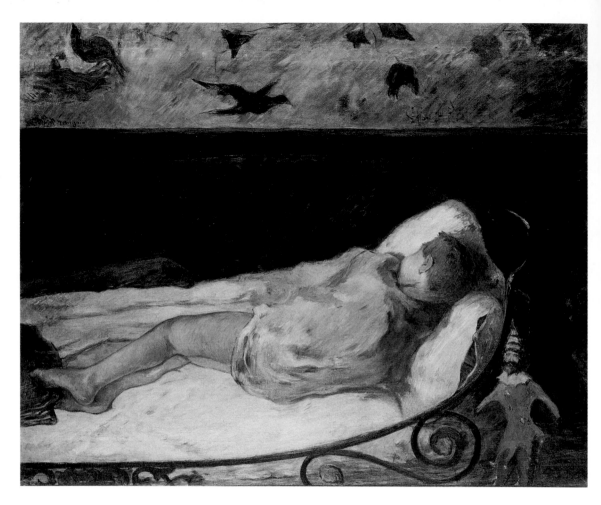

The Little Dreamer 1881
Oil on canvas 59.5 x 74.5 cm
Ordrupgaard, Copenhagen

PAUL GAUGUIN (1848–1903)

Aline

Of his five children, Gauguin was particularly fond of his only girl, Aline. He painted her at four years old, with cropped hair, sleeping in her metal sleigh bed. He had previously painted her brother, Clovis, asleep. The image of a sleeping child is often associated with Christ on his mother's lap – a prefiguration of his death. Here, though Aline's face is turned away, we can imagine she is sound asleep.

She lies still but her room appears strangely animated. The white sheet and pillow contrast vividly against the dark wall. On the wallpaper are flying birds with one bird seemingly about to dive down at her. Is it a real bird flying through the half-lit room? A bright, red-coloured doll dangles from the bedhead, but its outstretched arms and upright stance make it appear alive. Together with the odd birds, these motifs suggest her dreaming is not peaceful and may even be troubled.

At the time Gauguin painted this picture he was living in Paris and had not long been made redundant from his work in stock trading. He was acquainted with the Impressionists and followed their lead in painting their contemporary world, peopled by those who surrounded them. Families were frequently shown in their work and Gauguin also used his wife and children as models. But he wanted to go beyond representing the real world as it is experienced through vision. His separation from his fellow artists and one aspect of his individuality can be found in his ability to show metaphysical states of mind. He believed an artist should 'dream before nature', painting less what is before the eyes and more of what could be thought or felt.

Gauguin left Paris to explore less sophisticated environments in which to further his ideas. In Tahiti he created a special notebook for Aline filled with his writing, drawing and painting. She never lived to see the book. While still in Tahiti, Gauguin learned that his beloved twenty-year-old daughter had died from pneumonia.

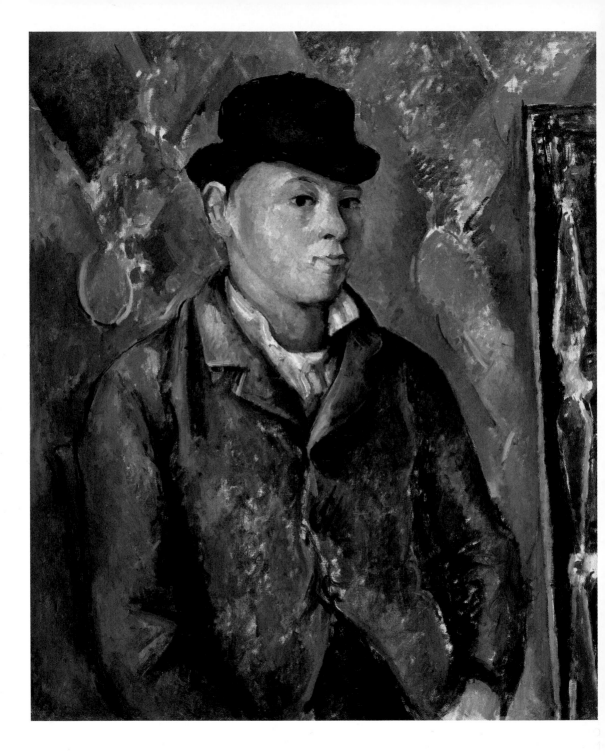

PAUL CEZANNE (1839–1906)

Paul

When he first became a father, Cézanne did not dare to tell his parents. Nor did they know about the existence of his mistress, Hortense, a model. Instead, he kept mother and child hidden well away from their home in Aix, Provence. Only when the boy, Paul, had reached six years old, did Cézanne's father learn about him. As a result, he reduced the financial aid he was giving Cézanne who, as an artist, was following a career he had not condoned.

For many years Cézanne worked apart from his small family. Even when he married Hortense the same year that his father died leaving him a large inheritance, Cézanne preferred an isolated way of life. At first he had exhibited with the Impressionists, but he wanted to make of their style 'something more solid and enduring, like the art in museums'. Hortense and young Paul lived mostly in Paris while Cézanne pursued his artistic ideals in the south of France. Painting the Provençal landscape became his growing obsessive preoccupation but in these, as well as in his numerous still-life and portrait works, he advanced painstakingly slowly.

The portrait of Paul aged about thirteen reveals Cézanne's unique style. The boy sits upright, staring, his mouth fixed, almost grinning. He wears a characterful hat that gives him more identity than any other aspect of the picture. It is said that Cézanne treated his portraits as if the figure were a still-life. He once asked his dealer to 'sit like an apple'. Behind Paul the wallpaper seems more three-dimensional than flat with its lively areas of light and shade. To the right a standing object, possibly a picture frame, is only partially glimpsed. Each strategically placed motif, including Paul, is made up of carefully applied, parallel brushstrokes resulting in a strikingly bold yet motionless composition.

Though his marriage had not been happy, Cézanne increasingly relied on the adult Paul. Paul managed his father's professional affairs once he became successful. Cézanne's work was later recognised as a forerunner of modern art.

The Artist's Son, Paul 1885–90
Oil on canvas, 65.3 x 54 cm
National Gallery of Art, Washington

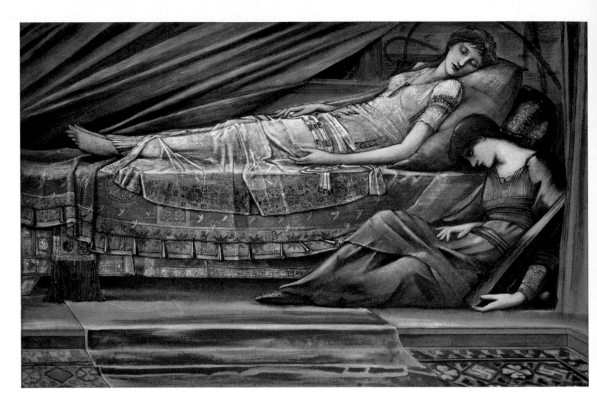

The Sleeping Princess 1886-88
Gouache with gold paint on paper, 97 x 149 cm
Private collection

EDWARD BURNE-JONES (1833–98)

Margaret

Burne-Jones and his close friend, William Morris, studied theology in Oxford with the intention of taking up professions in the church. By the time they had met Dante Gabriel Rossetti, and became acquainted with the Pre-Raphaelites, they changed their minds and turned towards artistic careers. Like other members of the group, they found inspiration in looking back at the medieval period which they portrayed with a romanticising nostalgia. They also felt a great love for poetry, admiring Alfred Lord Tennyson in particular. Burne-Jones was greatly influenced by Thomas Malory's *Morte d'Arthur*. The professional collaboration between the two friends helped to establish the aesthetic movement, towards the end of the nineteenth century.

The Sleeping Princess is the subject of one of a series of paintings known as *The Briar Rose* which together depict different views of a single moment in the story of *The Sleeping Beauty* by the Brothers Grimm. William Morris composed verses of poetry to accompany each painting. In this version Burne-Jones used his adult daughter Margaret to pose as the princess. He painted her in a characteristically idealised way that contributed to the image of the perfect Pre-Raphaelite woman, with fine, chiselled features and a dreamy kind of expression.

Margaret is said to have had a rather remote personality. As a teenager, she was described as being 'unnecessarily pretty' and the writer Henry James commented on her 'detached exterior'.

Burne-Jones was very possessive of Margaret. When she announced that she was to marry a family friend, he was shocked, believing her fiancé to have behaved with 'deep treachery' towards him. The wedding day arrived and the family was fearful he would react badly, but he bore the occasion with dignity. His wedding present to the couple was this very painting. Margaret and her husband visited several southern English towns on their honeymoon, including Glastonbury, which she said was 'a perfect setting to the Arthurian legends: one was in a dream of them all the time'.

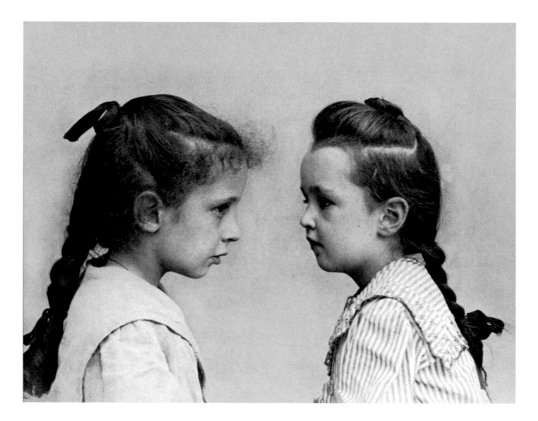

Jean and Geneviève Caillebotte c.1890s
Gelatin silver print, 20 x 26 cm
Private collection

MARTIAL CAILLEBOTTE (1853–1910)

Jean and Geneviève

The invention of photography, remarkable in itself for recording images, helped form new ways in which artists viewed the world. Towards the end of the nineteenth century painters frequently used photographs as the basis for realistic compositions of everyday life. The Caillebotte brothers worked in different media but often used their own relatives as subject matter. Gustave, an Impressionist, painted scenes of their social gatherings where each family member can be identified. Martial, with his camera, also recorded family occasions and frequently the brothers' compositions are similar.

Martial was primarily a musician, writing for piano and orchestra. He learned photography from his brother-in-law when his two children, Jean and Geneviève, were infants. Several of his photographs show them a little older, playing together and not dissimilar in appearance. Together they can be seen at the seaside or eating a meal in front of their elegant family home. In one photo they are not 'captured' but carefully posed before a hedge of flourishing hydrangeas as they charmingly lick spoons around a large metal pot. To modern eyes, Jean might sometimes be mistaken for a girl as he appears wearing a dress and with hair down to his waist, just like his sister's. Renoir, a family friend, painted them coiffed alike as they read books in an intimate interior scene. In the photograph where the two are posed facing each other, Jean is on the left. The two children's hairstyles are identical – a long plait down the back with a ribbon at the end.

Jean kept his long hair until he was ten years old, as was customary at the time. Taking three photos of 'before and after' the haircut, Martial Caillebotte carefully stood Jean with his long hair next to Geneviève. Then he had him sitting alone with the long tresses clearly seen. Finally he stood, his hair shorn to ear length. The images bear witness to the time when Jean left his sister behind, passing from early childhood to become a young boy.

Jean and Geneviève Caillebotte Licking Spoons Around a Pot in the Garden at Montgeron c.1890s
Gelatin silver print, 11.5 x 14 cm
Private collection

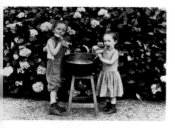

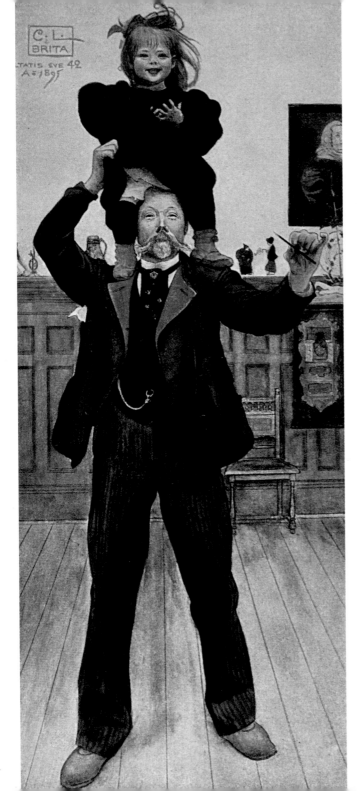

Brita and Me 1895
Pencil, ink, watercolour and
gouache on paper, 64 x 28 cm
Nationalmuseum, Stockholm

CARL LARSSON (1853–1919)

Brita

When Carl Larsson was shown his father-in-law's old home (where two elderly sisters still lived) he felt an immediate sense of tranquillity, declaring it to be the kind of place where he would love to live. He and his wife Karin were later given the cottage known as 'Lilla Hyttnäs' and over the years they transformed it into a unique home. Here they explored their ideas on interior decoration and created what came to be known as the Swedish Style.

The house needed to be extended to accommodate not only an increasing number of Larsson's large-scale commissions, but also a growing family. At the same time he turned his eye to his immediate surroundings, painting countless scenes of their lively domestic routine.

Brita was the fifth out of his seven children who survived infancy. One of several self-portraits he made shows her when she was two years old, laughing as she sits unsteadily on his head. Here he illustrates his view of himself as a father – someone who took part in his children's play. He holds what appears to be a wand but is probably his paintbrush, as if he is performing magic. Can he have been looking in a mirror when he painted the scene? Which room are they in – the artist's studio or a more formal place with pannelled walls and a Baroque portrait on the wall? Whatever the picture's true location, the mood of joyfulness between parent and child is the painting's essence.

Scenes of family life in their unique home were to bring Larsson enduring appreciation beyond his native country. But they were not what he considered to be his most significant work. The large-scale murals he made for public buildings and especially his *Midwinter Sacrifice*, a scene from Swedish mythology for the National Museum in Stockholm, were not immediately recognised. However, he knew the family scenes would become 'the most immediate and lasting part of my life's work. For these pictures are of course a very genuine expression of my personality, of my deepest feelings, of all my limitless love for my wife and children.'

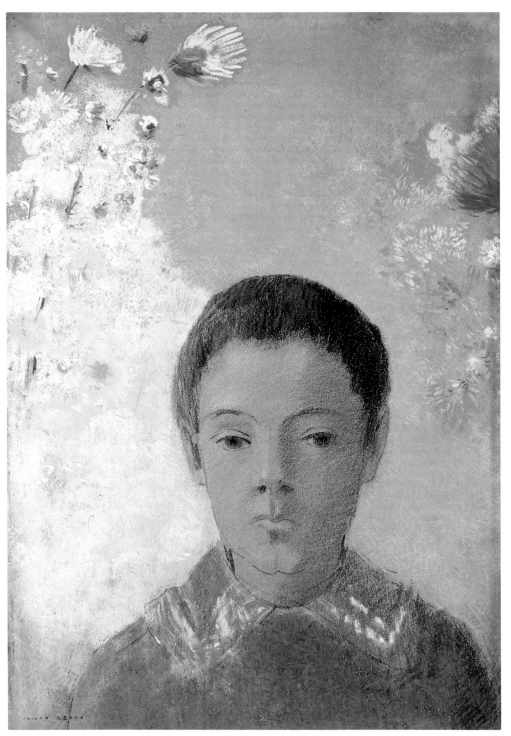

ODILON REDON (1840–1916)

Arï

'The affection of the father is the very creation of his child: it is his prize, his conquest, his triumph. And this infinite attachment – which is a certainty – is a mystery when broken.' Redon wrote these words after his first child, Jean, had died at six months' old. Two years later he and his wife had another boy, Arï, and when the baby's health was assured, his joy was ecstatic. 'Everything's going well at last,' he wrote to his mother, 'so well, that I'm afraid. It's too beautiful!'

Over the coming years Redon drew and painted Arï many times. The spiritual light and great happiness his son gave him coincided with a change of style in his work that exuded brilliant colours in unusual juxtapositions. Previously, up until he was nearly fifty, he had explored the use of black in charcoal drawings and in his lithographic work. Now colour became the means with which he illustrated fabulous, dream-like states. During his own childhood he had spent hours outside 'watching the clouds pass, following with infinite pleasure the fairytale brilliance of their incessant changes'. In his late work Redon avoided outline, often using pastels, or oil resembling the pastel technique, to achieve the imprecise and indeterminate. His colours gained a striking sensuousness. Portraits are accompanied by details from nature to create decorative patterns across the picture surface. Forms appear in coloured space, weightless, as if moving, yet never are the paintings entirely abstract. His world is visionary and mysterious.

Arï's head and shoulders are balanced by a sweep of dazzling, pale light from which flowers grow. These reach over to another floating bouquet. Their blues match the boy's pullover that keeps him firmly grounded to the picture's base. Arï's delicate features are carefully drawn and finely coloured. His mouth is fixed, as if he is concentrating, and he gazes out to an unseen point. Redon compared a child to a poem, claiming that though you read the stanzas one by one, it was the poem's overall charm that followed you everywhere.

*Portrait of Arï Redon c.*1898
Pastel on paper, 44.8 x 30.8 cm
Art Institute of Chicago

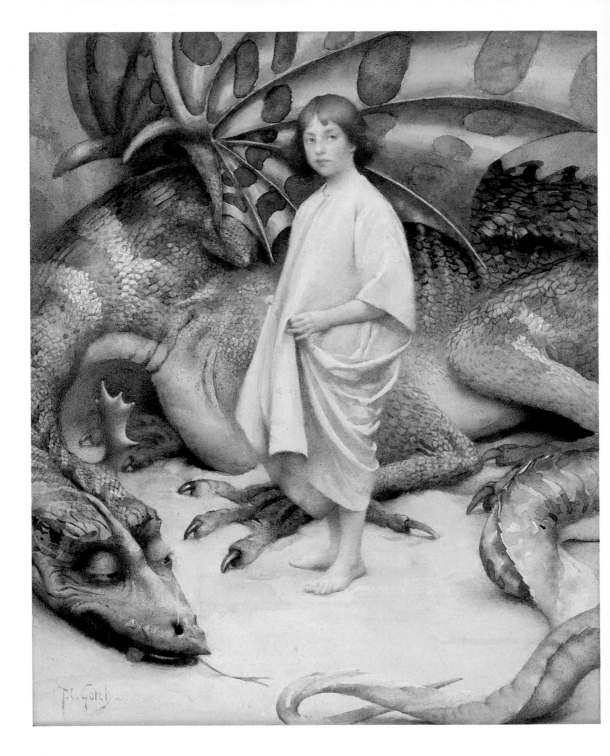

THOMAS COOPER GOTCH
(1854–1931)

Phyllis

'I try to help people understand the more beautiful and more spiritual sides of life, those emotions that are difficult to express in words but which the artist can express with his brush.' In explaining his aims, Thomas Cooper Gotch revealed his frequent departures from the subject matter more commonly used by his fellow artists of the Newlyn School in Cornwall. The village inspired paintings of fishermen, their lives and their seaside location, but Gotch was frequently moved to illustrate more abstract ideas through portraying his daughter, Phyllis.

He first painted her when, aged eight, during a trip to Italy, she was bored and restless. To quieten her, Gotch encouraged her to pose. Symbolism was becoming a new means of expression for him. His painting *Innocence* is based on an earlier oil painting called *The Child in the World*. Here Phyllis is seen standing calmly where a fantastic dragon is coiled about her bare feet. He described the child 'standing alone and unafraid in the innermost, horridest home of the Dragon, called the World, who is powerless against her innocence'. In order to present the fictive animal realistically, Gotch had researched dragons in various books on heraldry. He was disappointed when critics found the painting amusing, comparable to a scene from pantomime rather than a serious allegory. In the later, smaller, watercolour version he was able to realise a much finer handling of the subject – and changed its title. This time it found a buyer before it was even exhibited.

Phyllis posed for many more of his striking, symbolic works where the influence of Italian painting, so loved by the Pre-Raphaelites, can also be detected. His fascination with her, an only child, allowed Gotch to explore the idea of the death of innocence as the child moves towards adulthood. Once grown, Phyllis became a lively member of the Newlyn community and was remembered by the artist Laura Knight who said of her, 'had she been a General she could have led millions to death and glory for a hopeless cause'.

Innocence 1904
Watercolour on paper, 23 x 19 cm
Falmouth Art Gallery, Cornwall

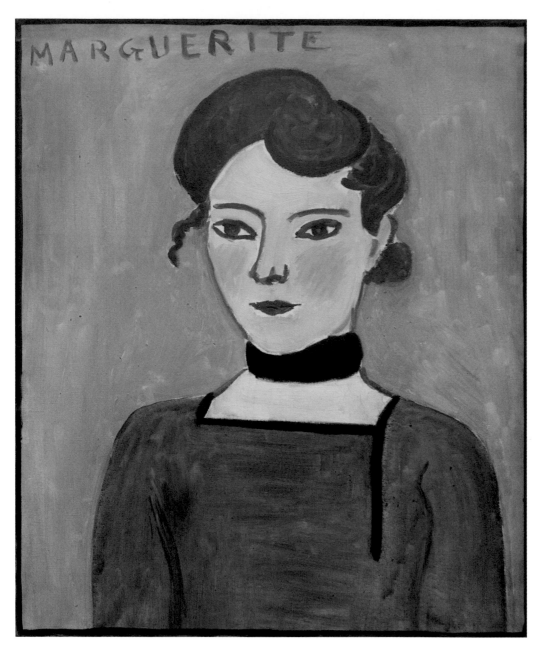

Portrait of Marguerite 1907
Oil on canvas, 65 x 54 cm
Musée Picasso, Paris

HENRI MATISSE (1869–1954)

Marguerite

When she was only six years old, fighting for breath, Marguerite Matisse had an emergency tracheotomy. She was held down on the kitchen table by her father. Her throat was slit by the doctor, allowing in air, and she survived. From then on she suffered a fragile state of health and would wear round her neck some kind of clothing, such as a black ribbon or high collar, to hide the three-inch scar that had been made there.

Matisse had painted her before, in recognisable domestic scenes, but when she was eleven years old he created a very different kind of portrait of Marguerite. Facing slightly to the side, her fixed mouth and eyes suggesting serious concentration, the bold image is very simply drawn in outline with areas filled by a limited range of colour. Only a few years earlier Matisse and other painters had been branded as Fauves (wild beasts) at an exhibition in Paris. Critics had been appalled by the slapdash nature of their paint application and their use of strong colours that did not seek to imitate nature. Although her pink skin is life-like enough, the stark colour of Marguerite's neck-ribbon is repeated in the strong lines of her dress, her hair and facial features. Light and shade are banished in favour of a flatness that is purely decorative. Her name is included, painted in a child-like scrawl across the top of the picture.

'The simplest means are those which best enable an artist to express himself,' Matisse wrote a short while later. At the same time, Picasso was also making moves towards representing the world in an unconventional way. The two artists had begun careers that were to dominate twentieth-century art. When they invited each other to choose a painting from their work, Picasso chose the portrait of Marguerite.

She was the child of an early liaison, yet when Matisse later married and had two sons, Marguerite busied herself with them and the running of her father's studio. So reliant on her caring nature did the family become, she was nicknamed 'the doctor'.

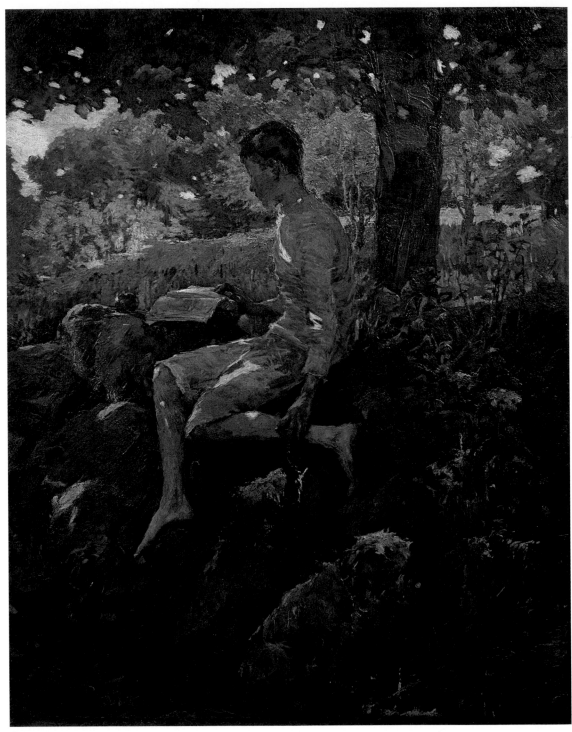

ELIZABETH FORBES (1859–1912)

Alec

Newlyn is a small fishing village near Penzance in Cornwall. Towards the end of the nineteenth century English artists followed the example of the French who had sought remote, beautiful places in which to work. Cornwall greatly appealed to them. Elizabeth Forbes had been painting and exhibiting for nearly ten years when she and her mother settled in Newlyn. Here she became a prominent personality in the artistic life of the small town. Here, too, she met her husband, Stanhope Forbes, also a painter. Together they founded a school of painting that gained wide recognition for its original style – one that revealed the fresh, out-of-door activities of Newlyn's people living near the sea.

Their son Alec was born in 1893. He was described by a friend as 'that little fair-haired son whose future fills so large a space in his parents' hopes and aspirations'. Even as an infant, Alec became a prominent figure in Elizabeth's work. With no brothers or sisters, he was content to amuse himself by reading as she painted. At this time, children's

book publication was flourishing with beautifully illustrated tales of adventure and daring.

Alec is shown sitting outside on a shaded bank. The sun strikes a distant meadow and reaches through the branches above him. Though his two dogs are alert, standing at his bare feet, their peaceful, cool location allows him to concentrate on his book. The title explains it is his holiday and his tall frame suggests he is not a young child. Nor is he yet an adult. He simply lives a quiet moment of undisturbed time, at home.

Besides painting, Elizabeth wrote and illustrated a fairytale, *King Arthur's Wood*. The protagonist, a boy called Myles, was based on Alec and his idyllic Cornish childhood. In it she wrote, 'To my little friend and comrade, Alec. This book is dedicated with his mother's love.' Later Alec trained to be an architect but as he was finishing his studies, the First World War broke out. He joined the army in 1915 and was killed in action the following year.

*The Half Holiday c.*1909
Oil on canvas, 122 x 96.5 cm
Penlee House Gallery and
Museum, Penzance

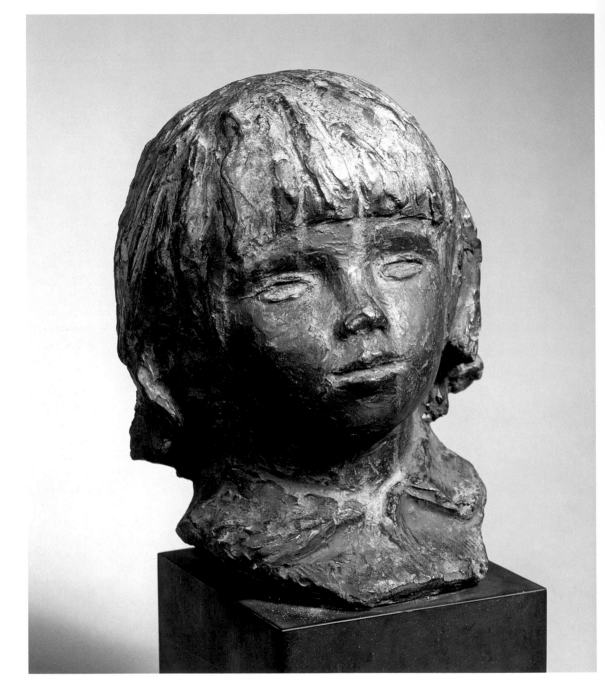

Claude Renoir ('Coco') c.1908
Bronze, 26.4 x 19.6 x 19.1cm
National Gallery of Art, Washington

PIERRE-AUGUSTE RENOIR

(1841–1919)

Claude

After a successful career as a painter, Renoir came to sculpture late in his life. He had much in common with his contemporary, the sculptor Aristide Maillol, whose work revealed a respect for the art of the classical era. Like him, Renoir had a preference for creating large statues of nude, female figures. Most of these were created while he lived in the south of France – a warm place that he hoped might alleviate his suffering from rheumatoid arthritis. He continued to paint with brushes though their wooden handles hurt his fragile skin. To compensate, cloth was placed in the palms of his increasingly deformed hands so that his grip could remain secure. Sculpture, with the help of an assistant, provided an alternative medium to painting which Renoir used for many portraits of his friends and family.

The youngest of his three boys, Claude, nicknamed 'Coco', was one of his favourite models. He was born when the artist was sixty. Claude's older brother, Jean, wrote the celebrated biography *Renoir, My Father*, in which he remembered their earlier life when 'Coco certainly proved one of the most prolific inspirations my father ever had'. The young six-year-old appears in a lightly sketched chalk drawing that was a preparatory work for a later painting. Claude is seen in profile working at his own little easel and one cannot help thinking that perhaps father and son were cheerfully employed in painting each other. 'My brother Claude spent the greatest part of his time posing,' wrote Jean.

Several versions of a bronze sculpture exist which show Claude about a year later, still with his heavily fringed head of hair, below which his fine features emerge. His young face looks upward. The base of the sculpture is terminated by the suggestion of a shirt collar which also contributes to framing the face. Renoir's light painting technique of decades earlier, when he was established as one of the founding members of the Impressionist group, is brought to mind in the way the rough surface of the bronze is handled.

The Artist's Son Claude or 'Coco' c.1906
Red and white chalk on paper,
31.5 x 27.1 cm
National Gallery of Art,
Washington

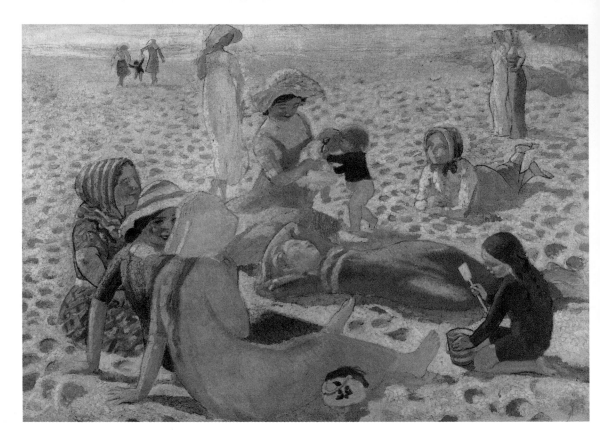

The Beach (Little Boy at the Beach) 1910–11
Oil on canvas, 80 x 118 cm
Clemens-Sels Museum, Neuss

MAURICE DENIS (1870–1943)

Noële, Anne-Marie, Bernadette, Madeleine and Dominique

Writing in his diary as a boy, the young Maurice Denis believed he should be a painter of Christian miracles. Religious themes appear in much of his adult work and he was an obvious choice for commissions to paint large panels for the interiors of churches as well as other public buildings. His individual symbolic style grew from sympathy with his contemporaries' new ideas, especially Gauguin's, as well as a knowledge of earlier Italian art. He was a founder member of a group known as the Nabis who saw themselves as prophets of a new kind of painting – in flat, pure colours that emphasised decorativeness above realism.

When Denis married, he frequently portrayed his wife, Marthe, as a Madonna-type with one or several of their children. He found ways in which to infuse scenes of their everyday life with deeper meaning. In 1908 he bought a seaside house in Brittany. He had always loved the sea, its mysterious beauty and its power to evoke both ancient myths and the spirituality of his religious thought. Each summer he took his family to their new home. 'What strikes me most is the convenience of the house to my lifestyle, that of the children and of painting – the beach and the studio. And also, there's the wood, and there's solitude and the most beautiful sunsets . . .'

The sunny painting of children on the beach centres upon his newest born child, Dominique, the baby. The other children (on the left, his three oldest girls, with one more on the right) are seen with their admiring friends. Behind the tight-knit group are more female forms who simply populate the beach where, in the distance, two girls play with another child. The bright colours, though not naturalistic, evoke a joyfulness reminiscent of a painting by Matisse a few years earlier entitled *Le Bonheur de vivre (The Joy of Life)*. The sunlight is almost harsh yet subdued by patterns and dashes of blue. The whole scene, as well as being a celebration of the 'golden age of childhood', can be thought of as a tribute to the nurturing power of the feminine.

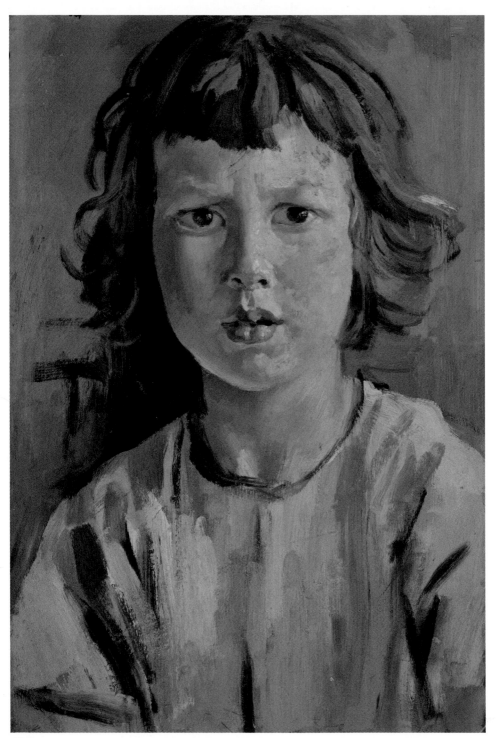

68

AUGUSTUS JOHN (1878–1961)

Robin

Augustus John was fortunate to attend the Slade School in London at the time when its celebrated teacher, Henry Tonks, first arrived there. Tonks, once a surgeon, placed emphasis on drawing from life. He recognised that John had a precocious talent that even inspired other students. John married one of these fellow students, Ida Nettleship, and though without much money, they both intended to pursue their careers in art.

In six years they had five boys, Robin being the third, after which Ida declared she would never have another baby. Some six months afterwards John's mistress, Dorelia McNeill, gave birth to the first of her four children by him. This unusual *ménage à trois* was monopolised by the children. At times the bohemian family adopted the life of gypsies, living in a caravan, an ideal that John had dreamed of from a young age. But as the children became more numerous, so John found they prevented him from working. He reacted to them with severity,

once claiming that Robin radiated hostility towards him. 'I fear I shall reach a crisis and go for him tooth and nail,' he wrote, explaining he had done so once, '. . . and I soon floored him on the gravel outside'.

The portrait of Robin, painted when he was eight, shows a boy in no tranquil state or peacefully occupied. The furrowed brow and slightly open mouth reveal a questioning, spirited child. He appears to be in mid-speech, though it was his silences that annoyed John. Assured brushstrokes, thickly applied, follow the movement of his hair and are repeated in his shirt. The whole close-up view is charged with energy.

Not long after Robin's mother died, John wrote, 'I begin to see how it is all going to come about – all the children and mothers and me. In my former impatience and unwisdom I *used* to think of them sometimes as accidental or perhaps a little in the way of my art, what a mistake – now it dawns on me they are, must be the real material and soul of it.'

Robin c.1912
Oil on panel, 45.1 x 30.5 cm
Tate, London

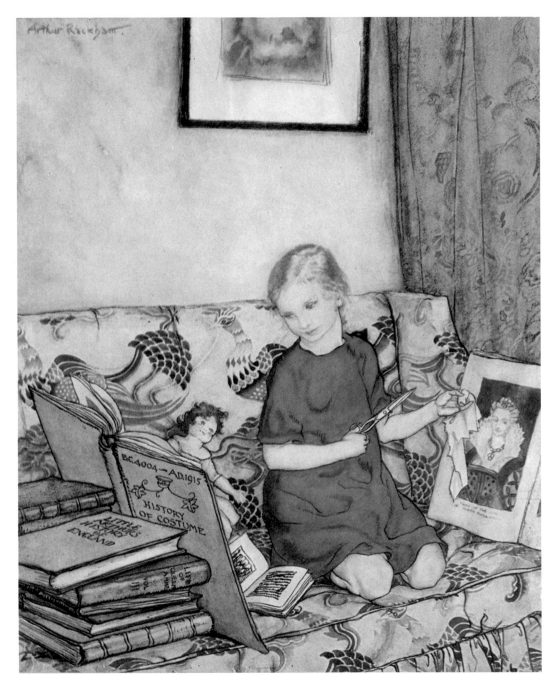

A Portrait of the Artist's Daughter, Barbara 1915
Pen and ink and watercolour on paper, 33 x 26 cm
Private collection

ARTHUR RACKHAM (1867–1939)

Barbara

As a child, Arthur Rackham is said to have hidden pencil and paper under his pillow in order to carry on drawing at night. He included pictures in the letters he wrote. Being one of twelve children, the household revolved around the activities of himself and those siblings who survived beyond childhood. When he himself married, he had only one daughter, Barbara.

Rackham looked back to the mid-sixteenth-century work of engravers such as Dürer and was stimulated in his own time by changes in printing technology when woodblocks were replaced by a photomechanical line block process. A limited use of only three colours helped him create a striking, occasionally strange, yet entirely imaginative style that suited the wide range of literature he illustrated. Drawing in pencil first, he later applied confident ink outlines to reveal his fabulous world of fantasy and fairy folk.

A year after the First World War had begun, a collection of stories and poems, *The Queen's Gift Book*, was published in order to raise money for hospitals for wounded soldiers and sailors. Amongst other celebrated writers and artists, Rackham was invited to contribute. He made two black and white drawings and used his daughter as a model in the colour illustration for a story called 'The Soot Fairies'. Barbara is seen as Beryl, who, at the beginning of the tale, is quietly making a historic costume for her doll before numerous black fairies appear down the chimney and surprise her. The sofa cover, the curtains and the heavy, old books are clearly delineated then washed with colour. On the back of the drawing Rackham wrote, 'Beryl decides to dress Arabella Stuart like the little Elizabethan lady,' as well as precise instructions to his framers, who were to return the picture to his home address.

'I can only say that I firmly believe in the greatest stimulating and educative power of imaginative, fantastic and playful pictures and writings for children in their most impressionable years,' Rackham said. His words help to explain his great success in the field of children's book illustration.

Jaroslava and Jiri – the Artist's Children 1919
Oil on canvas, 82.8 x 82.8 cm
Mucha Museum, Prague

ALPHONSE MUCHA (1860–1939)

Jaroslava and Jiri

A chance telephone call altered the career of Alphonse Mucha. Whilst helping out in a print publisher's studio in Paris, he volunteered to design a poster that the famous actress Sarah Bernhardt urgently requested. Its success led them to work together frequently. His elegant, linear designs with their unusual pale colouring set the fashion for theatrical posters, which by 1900 became known as the Mucha style. He has since been associated with Art Nouveau, though he disliked this label, believing that art should not be of a specific period, but have an eternal and spiritual significance.

When his second child, a son, Jiri, was born he was working on a series of twenty large mural paintings. *The Slav Epic* depicted the history, mythology and strength of his native Czech people. One of his studios for the work was in an old castle which became Jiri's first home. Mucha had dreamed of creating this work, which took him eighteen years to complete.

Mucha often painted Jiri and his sister, Jaroslava, using them as models for his illustrative work. One appealing double portrait of the children shows little of the theatrical Mucha style in its intimacy and free handling of oil paint. They sit close together, smiling out of the picture, accompanied by their toys. In a later oval portrait of Jiri alone, he is seen not with such symbols of childhood, but holding paintbrushes. He is posed as if he were an adult artist. Though Mucha encouraged his son to paint, it was Jaroslava who took up the profession and greatly contributed to the restoration of *The Slav Epic* after the canvases had been badly stored.

Jiri became a writer and in his biography of his father's life and art he provided a valuable insight into the way Mucha had worked: 'It was a paradox characteristic of my father's life that again and again that aspect of his art which was most conditioned by fashion brought him most fame . . . for his work was simply art, and his personal gift to draw and paint.'

Portrait of Jiri 1925
Oil on canvas, 72 x 65 cm
Mucha Museum, Prague

MARC CHAGALL (1887–1985)

Ida

When his daughter was born, Chagall was so disappointed he had not had a son, he would not visit her and his wife for several days afterwards. Early on, however, he made an intimate pencil drawing of the mother staring affectionately at her sleeping baby. He claimed to be a bad father. 'She yelled so loud I couldn't keep from dumping her furiously on the bed,' he wrote in a passage of his extensive autobiographical writing. 'I can't stand children's piercing cries. It's frightful!'

Exiled from Russia after the First World War, Chagall and his small family frequently moved. Even when they settled in Paris, Ida (nicknamed 'Idotchka') was to have no formal schooling, but learned from several private teachers. The threesome became unusually close, speaking Russian at home, and Ida was to prefer the company of her parents and their friends to children of her own age.

Chagall did not like to paint portraits, especially where physical likeness was required. Early work of his hometown on the Russian-Lithuanian border shows its inhabitants in a dream-like version of their lives, more akin to colourful folklore than to harsh reality. Living in France, he was bound to recognise the recent achievements of French artists and during a holiday in Brittany, he painted Ida sitting at a window, looking out to sea. She appears much older than her eight years. In firmly placing the young figure next to a vase of flowers, in pale tones that resemble watercolours, he managed to achieve a sense of calm that reflects the peace the family had at last obtained in the country that was to bring him his greatest success.

Ida and her father were to become closer in later years, especially when, as an adult, she was instrumental in facilitating their move, with his paintings, to the United States when anti-Semitism in Europe was growing. Devotedly, she translated his writing and organised many exhbitions of his work ensuring the survival of his international reputation.

Ida at the Window 1924
Oil on canvas, 105 x 75 cm
Stedelijk Museum, Amsterdam

PABLO PICASSO (1881–1973)

Paulo

By the time his three-year-old son posed for this painting, Picasso had achieved a remarkable reputation in European art. Throughout his long career he explored different ways in which to represent his ideas, frequently using the same subjects yet changing styles. The character of Harlequin first appears in his work in the early 1900s. Settled in Paris having left Spain, Picasso liked to visit the circus and the theatre. Apart from watching their shows, he made friends with the performers. Several times he painted an adult Harlequin showing not the fictional character, but the actor with his real family off-stage.

For the young Paulo, dressing up in fabulous costume was a natural activity. His mother, a ballerina, had belonged to Diaghilev's celebrated Ballets Russes when Picasso met her in Rome. During Paulo's childhood, fancy-dress outfits were made for him to attend parties and although they often represented adult characters, their designs were suitably appealing for children.

Harlequin was a traditional stock character from the Commedia dell'Arte – an acrobatic, comic servant who wore a dark hat, a mask and an outfit made of bright, patchwork pieces. In his unfinished painting, Picasso lays emphasis on the costume – its colouring and pattern against a stark, black chair. Paulo was also painted as Pierrot, the character of the white-faced clown, pining for his love. Other theatrical disguises found their way into Paulo's wardrobe – a jockey, a soldier and, owing to his father's nationality, a Spanish bull-fighter. He was even filmed in this costume with his nanny playing the part of a bull.

Once, when Paulo was sleeping, Picasso picked up a model motorcar and painted inside it a check patterned floor. The boy woke and on seeing it altered burst into tears. Later in life, Paulo's love of real cars encouraged him to work closely with Picasso's chauffeur whose role he virtually took over, though he never adopted his uniform.

Paulo as a Harlequin 1924
Oil on canvas, 130 x 97.5 cm
Musée Picasso, Paris

OTTO DIX (1891–1969)

Ursus

Enlisting to fight for your country was an attractive ideal for many young men at the start of the First World War. They could not have anticipated the length of the war, nor what it would be like to witness the full horror of its carnage. Otto Dix fought on the Western front and took part in the Battle of the Somme. Afterwards, during peacetime, he suffered a recurring nightmare as a result of his experiences. As an Expressionist painter, he is well known for his realistic depiction of battle scenes as well as his more cynical work illustrating the decadence of German society in the Weimar Republic between the two wars. When the Nazis came to power, his work was considered degenerate.

Dix married and despite his earlier suffering, as the father of three children he enjoyed family life. He frequently painted his daughter, Nelly, and recalled the work of the German Romantic artist, Otto Runge, who located the child in a beneficent natural world. When Dix's first son, Ursus, was born he depicted the newborn child lying on its back, screaming. The baby's umbilical cord is shown, harshly tied, the cut end turning blue.

Another painting of his son's first hours is based on a sketch he did at the time of the birth. From his invisible vantage point Dix looks over his wife's head to her splayed abdomen and legs between which the midwife's hands enfold the newly exposed infant. Transferring the image into paint, Dix had been experimenting with his use of colour, applying it in layers to the smooth foundation of a wooden support. This was in imitation of the tempera or glazed techniques used by old masters that he combined to create a highly detailed finish. The wrinkly flesh of the ugly newborn baby is not dissimilar to the aged hands that hold it. The striking image appears as a reminder of the distance between birth and old age as well as the proximity of death at all ages. Ursus lies on a white cloth, held by hands that mysteriously emerge from a featureless background of darkness.

Newborn Baby on Hands (Ursus) 1927
Mixed media on wood,
50 x 43.5 cm
Staatsgalerie, Stuttgart

Portrait of Peggy Jean (The Sick Child) 1928
Bronze, 36 x 50 x 56cm
Leeds Museums and Galleries

JACOB EPSTEIN (1880–1959)

Peggy Jean

When many of Epstein's public sculptures were first unveiled they were looked at with horror and disbelief, encouraging prejudiced views that could have ruined his artistic ambition. Epstein wanted to 'create mountains'. His bold monumental work was the result of a singular vision which he refused to modify. His resilience paid off when, at the end of his life, he was widely recognised, even knighted. Looking back, he said that the 'only time I have ever been put out of humour by a criticism was when a particularly objectionable writer said "a child's soul is not safe in his hands"'.

For Epstein, the sculptor practised his art either in carving stone or by building up a work in clay. A bronze portrait head was achieved after a plaster cast was formed from an initial modelling in clay. 'As I see sculpture it must not be rigid,' he said, explaining these techniques. 'It must quiver with life . . . carving often leads a man to neglect the flow and rhythm of life.' Working up clay allowed him to capture the essential vitality and character of his sitters. Though he was asked to make many portrait busts of significant people of his time, he particularly liked to work with his own children.

He made the first of fifteen portraits of his daughter, Peggy Jean, when she was three months old. When she was ten, a small fragment of steel was blown into one of her eyes, temporarily blinding her. While she recovered, Epstein made his twelfth, very moving portrait showing her with drooping head and heavy lids. He included nothing of her body except both arms reaching out in front of her. She concentrates on what her fingers feel.

'To work from a child seemed to me the only work worth doing, and I was prepared to go for the rest of my life looking at Peggy Jean, and making new studies of her,' Epstein said much later. 'I regret that I have not done more children, and I plan some day to do only children. I think I should be quite content with that, and not bother about the grown-ups at all.'

ALEXANDER RODCHENKO
(1891–1956)

Varvara

Early in the 1920s, Rodchenko was making unusual experiments in photography. Just as his native Russia was facing a new era in its history, so he was able to declare that his work announced 'the end of painting'. He was a founder of Constructivism, a term that was originally derisive (as Impressionism had been) but that served to describe a movement where art's purpose was, above all, social. Rodchenko used many media in his career, but through his photography and its uses in graphic design, he was to become greatly influential beyond Russia.

The photograph of his daughter, Varvara, illustrates an idea he had about composition, that subjects could be shot from odd angles, high or low, in order to avoid the conventional viewpoint and therefore to surprise. Light falls from above on the large mass of wild flowers in the foreground and then on half of her face and shoulder.

'I want to make completely unbelievable photos, the kind that never existed before, pictures that are so true to life that they are life itself,' said Rodchenko. 'I want my photographs to be at once simple and complex, so that they will shock and astound people. I must achieve this so that photography can begin to be considered an art form.'

Varvara herself, when older, also became a photographer, graduating from the Moscow Graphic Institute in 1948. She lived on in the family apartment using her father's darkroom even after he had died. Devoted to the memory of both parents (her mother was also an artist), she worked towards preserving their work and wrote her memoirs of their life together. 'After 1924, my father's passion was photography, because of its novelty and its capacity for variety. An ineradicable part of his working life, it was also his main source of entertainment. He built himself a studio, painting the walls and ceiling black and installing tables for chemical baths and enlargers. He often went into this darkroom to "practice witchcraft", as he would say.'

Portrait of My Daughter
(Wild Flowers) 1935
Gelatin silver print, 29.6 x 20.7 cm
National Gallery of Australia,
Canberra

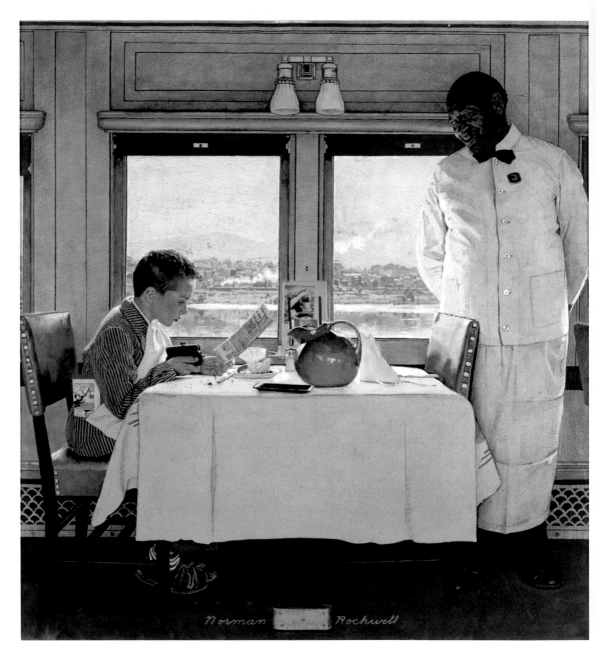

Boy in a Dining Car 1946
Oil on canvas, 96.5 x 91.5 cm
Norman Rockwell Museum, Stockbridge, Massachusetts

NORMAN ROCKWELL (1894–1978)

Peter

Described as 'America's most beloved painter', Norman Rockwell's art reached millions of readers of the *Saturday Evening Post*. His paintings were on the cover of this popular magazine for over four decades. He captured the spirit of the everyday life of Americans by illustrating single, immediately recognisable yet fictional scenes of their homes, their customs and activities. He used real people as his models, placing them in his studio in specific poses (often hard to maintain) that imitated a natural attitude or gesture. He carefully gathered the right kind of props that would accompany such scenes. The painstaking method in which he built up his pictures resulted in almost photographic representations – he didn't shun the use of the camera as an aid. He worked extensively in advertising and poster design and for the Boy Scouts of America, always with an eye for the arresting yet familiar.

Rockwell used his sons as models in some of his many images of children. His youngest boy, Peter, posed when he was ten years old as the child on the train who, staring at the bill for his lone meal, calculates how much he should leave as a tip. We can tell that he has eaten a small cake, probably a chocolate muffin. Tucked in his pocket is his preferred reading, a comic showing an illustration of Felix the Cat.

A real dining car was used, parked on a siding outside New York during a hot summer when Peter had to wear winter clothes. The kindly waiter was also taken from life – a genuine railroad employee. The image serves to explain the safety and freedom of travel for young people, even if occasionally a puzzling moment might crop up. The situation does not threaten. Rockwell's America is often portrayed as safe and sound for children and therefore optimistic for the nation's future.

Peter later recalled how, having posed for three hours in the heat, he was taken to FAO Schwarz, the celebrated New York toy shop, where he was bought a new truck as a reward for his work.

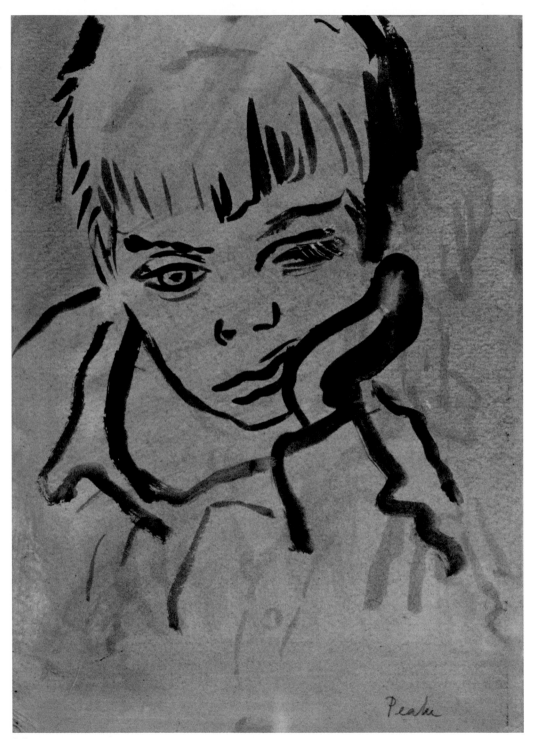

Peake

MERVYN PEAKE (1911–68)

Sebastian

The dark world of the Gormenghast books, populated by haunting, semi-grotesque characters, evolved from the fertile, visual imagination of a writer whose training and early successes had been in art. Peake carried a sketchbook about with him, using it to quickly make a note of the appearance of people he met in passing. Observing faces, gestures and idiosyncrasies he was, like Dickens, able to create a host of fabulous, imaginary characters that were born in reality. To illustrate his own books was a natural procedure for Peake and he said of *Titus Groan*, 'the drawings had formulated in my mind as I wrote'.

The earliest of the three completed Gormenghast books was begun not long after the birth of his first son, Sebastian, at the beginning of the Second World War. By the time it was published, the war was over and another boy had been born. The family decided to move to Sark, a place that Peake loved and where he enjoyed working. The beautiful island, cheaper than London and far more healthy for the boys, would prove conducive for everyone.

The sketch of snub-nosed Sebastian shows him aged eight and ill at ease. He was about to return to a strict Catholic boarding school on Guernsey where, despite its beautiful setting, it meant that 'the blissful freedom of Sark was over'. Sebastian recalled how the family's Moroccan gardener was given the task of driving him to the harbour, 'as I could not bear to be taken to the boat by my mother. Not because I didn't want her to say goodbye, but as I knew a public emotional break would be just too much to handle.'

Peake made countless studies of his children. If he captured Sebastian's mood through briskly painting the features of his face, he was following his own teaching on drawing. 'Do not be afraid to exaggerate in order to convey the real intention,' he said in a book entitled *The Craft of the Lead Pencil*. 'The drawing of heads is an inexhaustible study. One head alone could last a draughtsman's lifetime.'

Back to the Christian Brothers Boarding School, Les Vauxblets, Guernsey c.1947
Watercolour on paper
Private collection

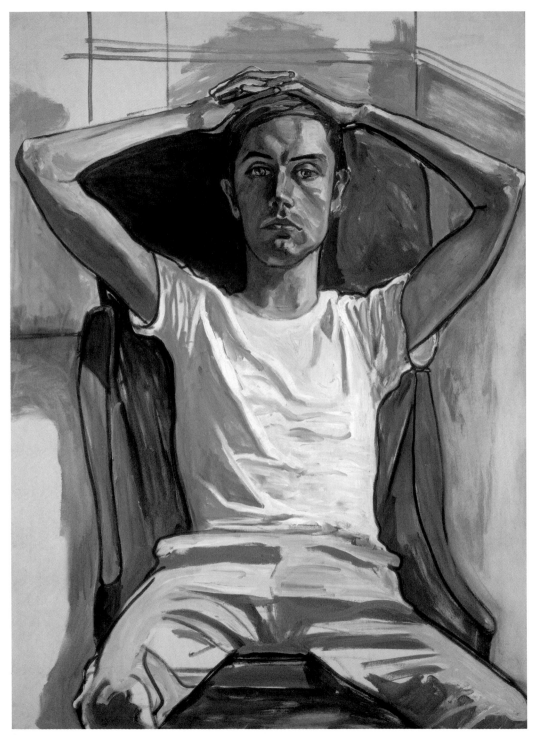

ALICE NEEL (1900–84)

Hartley

When, in 1955, Alice Neel was interrogated about her political leanings by FBI agents, they described her as a 'romantic Bohemian-type communist'. She asked if they would like to have their portraits painted. Her harshly truthful portraiture was the great achievement of her career in which she followed no school but developed her own distinct vision. Painting dominated her long, eventful life though she was recognised only in her last decades. Much of this later success was due to her exposure kindled by the Women's Movement. At the age of seventy-five she began her first self-portrait. It was completed four years before her death and showed herself naked.

'If I have any talent in relation to people apart from planning the whole canvas,' she said, 'it is my identification with them.' While bringing up her children, Neel created studios at home in several New York apartments. She spent many years in Spanish Harlem where Hartley grew up. Family, friends, lovers and even the strangers she met out in the street were the subjects of her forceful work.

At first glance the portrait of Hartley appears to be the image of a disgruntled teenager. Yet this was done at a time when the young man had succeeded in his early academic studies and had now begun medical school. He told her he did not like to dissect corpses and would have to give it all up.

Hartley sits in the corner of a room where strong light from the window falls on his bright, white T-shirt. The cool green of his trousers is repeated in his flesh tones. The compositional balance of his posture, with arms raised and legs apart, together with his fixed expression are confrontational. Stark, dark blue lines surround his angular frame and face.

Hartley did succeed in medicine and within ten years of this portrait being painted, he had a practice in Stowe, Vermont. For several weeks a year, Neel visited him and his family and eventually had a studio made at his home where she could continue painting. After her death, at her request, she was buried there.

Hartley 1966
Oil on canvas, 127 x 91.5 cm
National Gallery of Art, Washington

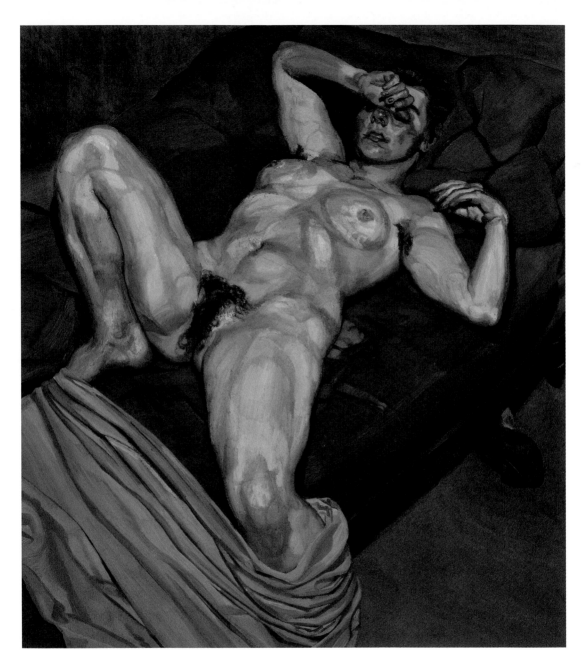

Rose 1978–9
Oil on canvas, 91.5 x 78.5
Private collection

LUCIAN FREUD (1922–2011)

Rose

'My naked daughters have nothing to be ashamed of,' said Freud on being asked about his portrayal of his adult children. To paint naked human flesh from close observation had been a growing preoccupation with Freud throughout his career, especially from the 1970s. Occasionally he would include his dogs in portraits, inviting a comparison between the two species. The paintings appear shocking at first, unlike representations of the nude throughout the ages where an emphasis on idealisation or beauty have dominated. Freud was interested in the form of the human body and how the bulk and stretch of flesh really appeared in the conditions of his studio.

In the portrait of his daughter, Rose, he looks down on to the bed where she lies. From this angle (as with many of his nudes) he is able to include most of the body. The genital area, interesting for its structure and colouring, almost takes up centre stage. The flesh tones are mostly reddish and warm and are highlighted by the specific bright white paint that he preferred for its lead content, which thickened and dried quickly. The loaded brushstrokes delineate the planes and form of muscle, bone and hair. Blue-greens are introduced to surround the central area. Rose has taken up a relaxed pose and seems to be slowly stretching, one leg and one foot in a sheet, her arms raised towards her head.

Freud had fourteen children and some have claimed there may be more. Their father's base was wherever he painted, not the different homes in which they lived with their mothers. Not having a conventional childhood, where he was often missing, did not prevent them from being willing to pose for him later when they could communicate with him more reasonably. 'There is something about a person being naked in front of me that invokes consideration,' said Freud. 'You could even call it chivalry on my part: in the case of my children, a father's consideration as well as a painter's. They make it all right to paint them. I don't feel I'm under pressure from them.'

Sam and the Perfect World 2005
Oil on linen, 112 x 117 cm
Milwaukee Art Museum

DAVID LENZ (born 1962)

Sam

In 2006 the Smithsonian National Portrait Gallery launched its first competition for innovation and excellence in contemporary portraiture. Over four thousand works of art were entered. As well as a generous cash prize, the winning artist would gain a further commission for a permanent place in the museum and a sound reputation was certain to follow.

David Lenz had been painting groups of people in specific social conditions. These included children in bleak locations in modern cities as well as the daily life of his neighbouring Wisconsin farmers. It was a single portrait of his son Sam, aged eight years old, that became his entry for the prestigious competition. As in his other work, the finished image is astonishingly photo-like, gained through several preliminary sketches and using photographs as references for minutely painted detail.

Sam appears alone in a bright, rural setting dominated by the sun and a huge halo. The green fields stretch away into the far distance. At first glance it seems that Sam's relation to the view is as a guide who is about to invite us into the pleasant 'perfect' world. Sam is, however, on one side of a barbed fence that separates him from that promising journey.

The painting won the competition and Lenz spoke out describing Sam's birth: 'Although he appeared perfectly healthy, something, nevertheless, didn't seem right. There was an awkward silence in the room, no words of congratulation or comments about how cute he was – even though he was cute. Five minutes later the diagnosis was given: Sam has Down's syndrome.'

Following Sam's birth and until the time of the competition, Lenz had considered creating a series depicting people with intellectual disabilities. His many achievements resemble a journalist's vision of people's lives. But in the careful selection and composition of his themes, as well as in his meticulous methods, his work reveals his own views. That his choice of subjects include the very young illustrates his idea that children 'after all, are the innocent bystanders of society'.

INDEX

Artists whose children appear in the book are in *italic*

ACKNOWLEDGEMENTS

The Publishers would like to thank those listed below for permission to reproduce the artworks illustrated in this book and for supplying photographs. Every care has been taken to trace copyright holders. Any copyright holders we have been unable to reach are invited to contact the publishers so that a full acknowledgment may be given in subsequent editions.

PAGE 2 Musée Calvet, Avignon, France / Bridgeman Art Library PAGE 8 RIGHT National Gallery of Australia, Canberra, purchased 1967 / Bridgeman Art Library PAGE 9 AND COVER Royal Pavilion, Libraries & Museums, Brighton & Hove / Bridgeman Art Library PAGE 11 Photo © Bonhams, London / Bridgeman Art Library PAGE 12 © Tate, London PAGE 13 Museum of Fine Arts, St Petersburg, Florida, museum purchase in memory of Margaret Acheson Stuart PAGE 20 Louvre (Cabinet de dessins), Paris / Giraudon / Bridgeman Art Library PAGE 21 Metropolitan Museum of Art, New York, gift of Mr & Mrs Charles Wrightsman, in honor of Sir John Pope-Hennessy, 1981 PAGE 26 © Victoria & Albert Museum, London PAGE 28 © Musée des beaux-arts et d'archéologie, Besançon, bequest of Charles-Antoine Flajoulot, 1840 / Cliché Charles CHOFFET PAGE 30 National Gallery, London, Henry Vaughan Bequest, 1900 / Bridgeman Art Library PAGE 32 LA County Museum of Art, Los Angeles, purchased with funds provided by Mr & Mrs Allan C. Balch Collection, Eloise Mabury Knapp, Mr & Mrs Will Richeson, Carlotta Mabury, John Jewett Garland, Celia Rosenberg, Mr & Mrs R. B. Honeyman, Bella Mabury and Mr & Mrs George William Davenport / Digital Image © Museum Associates and LACMA www.lacma.org PAGE 34 The Fletcher Trust Collection, Auckland, New Zealand PAGE 36 Guildhall Art Gallery, City of London / Bridgeman Art Library PAGE 40 Bridgeman Art Library PAGE 42 Ashmolean Museum, University of Oxford / Bridgeman Art Library PAGE 48 National Gallery of Art, Washington, Chester Dale Collection 1963.10.100 PAGE 50 Photo © Christie's Images / Bridgeman Art Library PAGE 54 AND BACK COVER Bonniers-Forlag, Stockholm / Archives Charmet / Bridgeman Art Library PAGE 58 Falmouth Art Gallery, Cornwall, purchased with funding from The Art Fund,

Falmouth Decorative Fine Arts Society, Dr Pam Lomax and Ron Hogg, Jacqueline and Richard Worswick (in memory of their daughter, Helen), and local funding / Photo © The Maas Gallery, London / Bridgeman Art Library PAGE 60 © Succession H. Matisse / DACS 2013 / Photograph © 2013 Archives H. Matisse PAGE 62 Penlee House Gallery and Museum, Penzance, Cornwall / Bridgeman Art Library PAGE 64 National Gallery of Art, Washington, gift of Margaret Seligman Lewisohn in memory of her husband, Sam A. Lewisohn 1954.8.2 PAGE 65 National Gallery of Art, Washington, gift of Mrs Paul B. Magnuson 1964.9.1 PAGE 66 © ADAGP, Paris and DACS, London 2013 PAGE 68 © Tate, London / Estate of Augustus John PAGE 74 © Chagall ® / ADAGP, Paris and DACS, London 2013 PAGE 76 © Succession Picasso / DACS, London 2013 / Musée Picasso, Paris / Bridgeman Art Library PAGE 78 © DACS 2013 PAGE 80 © Estate of Jacob Epstein (Tate, London) / Leeds Museums and Galleries (Leeds Art Gallery) / Bridgeman Art Library PAGE 82 © Rodchenko & Stepanova Archive, DACS, RAO 2013 / National Gallery of Australia, Canberra / Bridgeman Art Library PAGE 84 Printed by permission of the Norman Rockwell Family Agency © 1946 The Norman Rockwell Family Entities / Norman Rockwell Museum Collection PAGE 86 © The Estate of Mervyn Peake / Reprinted by permission of Petes Fraser & Dunlop (www. petersfraserdunlop.com) on behalf of the Estate of Mervyn Peake PAGE 88 © The Estate of Alice Neel / National Gallery of Art, Washington, gift of Arthur M. Bullowa, in honor of the 50th anniversary of the National Gallery of Art 1991.143.2 PAGE 90 © The Lucian Freud Archive / Bridgeman Art Library PAGE 92 © David Lenz / Milwaukee Art Museum, purchased with funds from the Linda & Daniel Bader Foundation, Suzanne & Richard Pieper, and Barbara Stein M2010.17 / Photo John R. Glembin

JULIET HESLEWOOD studied History of Art at London University and later gained an MA in English Literature at Toulouse. For over twenty-five years she lived in France where she devised and led study tours on art and architecture as well as continuing her writing career. Her books include *Mother: Portraits by 40 Great Artists*, *Lover: Portraits by 40 Great Artists*, *Introducing Picasso* and *The History of Western Painting* for young people which has been translated into twelve languages. Juliet now lives in Oxfordshire where she continues to write and is a freelance lecturer in History of Art.

The Author as a Child: Much of my happy childhood was spent outside dreaming. Boarding school, homesickness and puberty put an end to the ecstasy. When grown I was found to be sub-fertile so not having any children of my own, I enjoyed other people's and particularly loved being an auntie.

Discard